· CALLIGRAPHY ·
A Course in Hand Lettering

cio eum quia abipso et

pse memisit ; Quare

utem scio eum . quida

um &c; magnifice u

q; monstrauit . abipso

nquid quia filius dep

re ; et qui c quid ē filiu

le illo ē cuius ē filius . u

nm ihm dicimus . dm

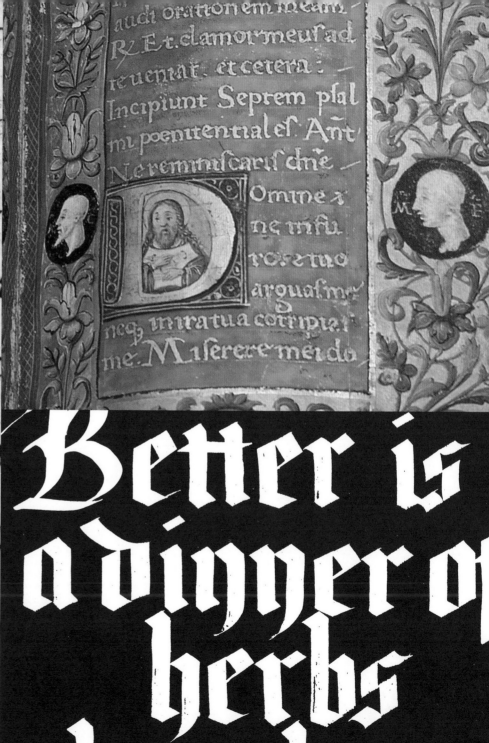

audi orationem meam

R. Et clamor meus ad

te ueniat. et cetera :

Incipiunt Septem pal

mi poenitentiales. Ant

Ne reminiscaris dñe

omine z

ne trifu

rose mo

arguas me

neq; in ira tua corripias

me. Miserere mei do

Better is
a dinner of
herbs

· CALLIGRAPHY ·
A Course in Hand Lettering

Maryanne Grebenstein

WATSON-GUPTILL PUBLICATIONS / NEW YORK

Dedication and Acknowledgments

As a child of about eight, I remember crawling into my grandfather's lap one sunny afternoon. As elders often do, he asked me about school. "What's your favorite subject?" he queried. He chuckled and responded "That's not a subject!" when I answered—with absolute sincerity—"Handwriting." I lovingly dedicate this book to my children and everyone who has helped me along my path, especially you, Pop.

It is with gratitude and sincere appreciation that I acknowledge those individuals who have helped bring this book to fruition. At the Boston Public Library, I am indebted to Dr. Earle Havens, Curator of Manuscripts, for his constant support and enthusiasm, as well as to Roberta Zonghi, Keeper of Rare Books and Manuscripts, and Barbara Davis, who tirelessly answered my questions and provided materials. To Dr. William Noel, Curator of Manuscripts at the Walters Art Museum in Baltimore, I offer my heartfelt thanks for his willingness to personally select several folios for inclusion in this book. My appreciation also goes to Christine Sciacca, Carol Bates Fellow at the Walters, for her patience in providing historic details. Thanks also go to Martine O'Byrne and Linda Montgomery at Trinity College, Dublin, for their help in granting me research privileges and providing the image reproduced here from the Book of Kells.

At Watson-Guptill, Inc., I will be forever grateful to Executive Editor Candace Raney for having faith enough in my initial draft to pursue its publication, and for her selection of book designers Eric Baker and Chris Cannon, whose magic transformed my myriad of text, drawings, and images into a thing of beauty. My thanks also go to Keitaro Yoshioka for his photographic wizardry.

I would be terribly remiss if I did not acknowledge my editor, James Waller. His guiding hand, keen attention to detail, and willingness to play the roles of historian, artistic director, researcher, photo editor, sounding board, and gentle friend, all in the interest of this publication, have contributed immeasurably to the final product. —MARYANNE GREBENSTEIN, MARCH 2006

Copyright ©2006 by Maryanne Grebenstein

First published in 2006 by
Watson-Guptill Publications,
Nielsen Business Media,a division of The Nielsen Company.
770 Broadway, New York, N.Y. 10003
www.watsonguptill.com

All original line art by Maryanne Grebenstein
Photography by Keitaro Yoshioka, unless otherwise noted

Library of Congress Cataloging-in-Publication Data

Grebenstein, Maryanne.
 Calligraphy : a course in hand lettering / Maryanne Grebenstein.
 p. cm.
 ISBN-13: 978-0-8230-0553-6
 ISBN-10: 0-8230-0553-4
 1. Lettering--Technique. 2. Calligraphy--Technique. I. Title.
 NK3600.G835 2006
 745.61--DC22

 2006010205

Executive Editor: Candace Raney
Editor: James Waller, Thumb Print
Designer: Christopher Cannon, Eric Baker Design
Graphics Production: Ellen Greene

Manufactured in China

First printing, 2006

3 4 5 6 7 8 9 / 14 13 12 11 10 09 08 07

Contents

Welcome to Calligraphy

THE BOOK YOU HOLD is a comprehensive beginning course in calligraphy, created to let you teach yourself the beautiful art form of broad-edged pen lettering. I've created it specifically for students who have little or no previous experience in the lettering arts, and I very much hope you'll find the book fun and educational.

Calligraphy requires careful attention to detail. The characteristics of a hand-lettered alphabet can be dramatically altered by, for example, changing the angle at which the pen is held—a nonexistent concern when using a modern-day writing instrument such as a ballpoint pen or felt-tip marker. Consistency in lettering—the quality that separates amateurish from professional-looking lettering—takes time and is achieved only through practice, through objective criticism of your work, and through study of examples of high-quality lettering.

Calligraphy also requires intense concentration, and therein lies part of the joy of lettering. Many people find calligraphy to be therapeutic—akin to yoga or meditation—because it forces them to stop rushing. The concentration demanded to perform each individual stroke makes us let go of some of our everyday busy-ness.

PRONOUNCEMENT OF MARRIAGE

John and Maryanne, inasmuch as you have pledged your faith and love to each other and have committed yourselves to this new relationship, I pronounce that you are now husband and wife—in accordance with the deepening and renewing promise of God's fulfillment and grace. May the blessings, the grace and the peace of life remain with you, and may you be blessed with many happy years together.

John and Maryanne, your journey of promise and hope continues on from this moment of shared commitment. Seek through your lives together peace with love, love with understanding, understanding with knowledge, knowledge with trust, trust with hope. Explore together the deepest mysteries of life, and discover for yourselves your own convictions, your own joys, your own dreams.

Professional calligraphers today are often commissioned to create display pieces and documents marking significant life occasions: births, marriages, retirements, deaths. This "Pronouncement of Marriage" was from my own wedding ceremony. I modeled the floral decoration used here after the vine illuminations that are so common in Renaissance manuscripts. The text lettering is Italic, but I chose to do the heading in a modified, modernized version of the Uncial hand. Like many of today's calligraphers, I often use two or more lettering styles in the same document—a contrast that, if carefully thought out, can make a piece more visually striking.

If this slow-down-and-enjoy advice sounds old-fashioned, it is! Lettering with pen and ink has been used to record the written word since the fourth century. Calligraphy really flourished during the 15th and 16th centuries—a period during which many elaborate manuscripts were created. Most were religious documents hand-lettered in the scriptoria (copying rooms) of monasteries or devotional books commissioned by royalty and other wealthy patrons and made in lay workshops. Many of these rare books survive, and the enchanting illustrations (known as illuminations, or miniatures) they often contain give us glimpses of daily life during the Middle Ages and Renaissance.

Despite the invention of the printing press and, much more recently, the advent of the personal computer, calligraphy continues to thrive. Today, it is used for elegant, hand-lettered invitations and greeting cards; for certificates and other testimonial documents; and, among professional graphic designers, for logo design, communication art, and, of course, font design.

So, as we begin this course in hand lettering, remember: *slow down.* Enjoy the unhurried, deliberate moves your hand makes with the pen. Don't worry about creating a masterpiece. Relax—and enjoy the process of learning.

A large and colorful *M,* the first letter of the name Matheas (Matthew), dominates this page from a Gospel book created at the Benedictine monastery on the island of Rheingau, in Germany, in the 11th century. Such *decorated initials*—often extremely ornate and incorporating floral motifs—are common features of hand-lettered manuscripts from medieval times through the Renaissance. This manuscript, now in the collection of the Walters Art Museum in Baltimore, is in the Carolingian hand—or, as it is sometimes referred to by historians, Caroline Minuscule.

MS. no. W7, folio 10r. Copyright: Walters Art Museum.

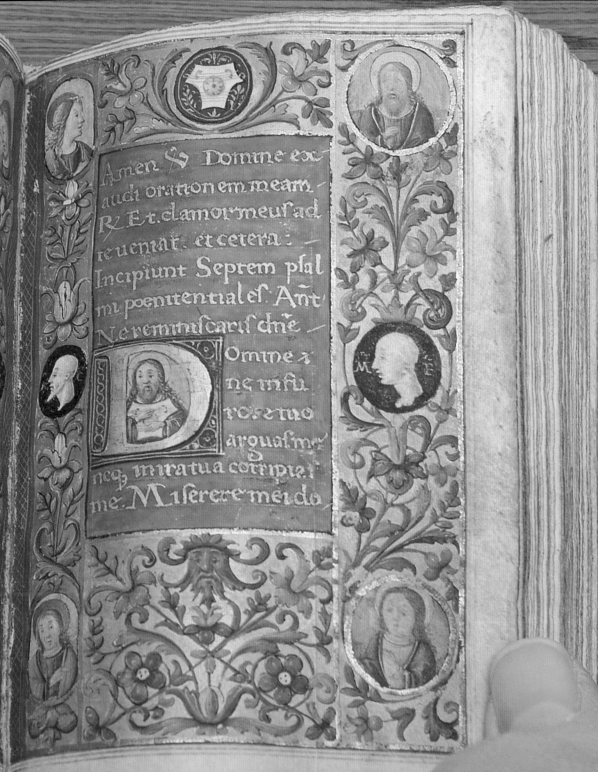

This glorious page comes from a late 15th-century Italian book of hours in the Boston Public Library's rare book department. Books of hours were prayer books containing a series of prayers known as the Hours of the Virgin (or, sometimes, the Little Office of the Blessed Virgin Mary). Commissioned by wealthy patrons, books of hours were typically executed by lay (as opposed to monastic) calligraphers. Books of hours are usually lavishly and beautifully decorated with gold illuminations and miniatures, and this manuscript, written in Carpi, Italy, by a scribe called Sigismondo de Sigismondi, is no exception. The entirety of the page shown here, which is vellum (calfskin), not paper, is suffused with color—a combination of paint and gold-leaf gilding.

The large gold *D* near the center of the page encloses an image of Christ. Art historians refer to this kind of element—a large capital letter containing a miniature painting—as a *historiated capital*. The medallions in the border surrounding the vibrant red rectangle at the page's center are of two kinds: those at the corners portray haloed saints or biblical figures, while those to the left and right of the central element probably depict "contemporary" people—perhaps the patrons. (Books of hours often contain such portraits.) The lettering style is one that art historians refer to as Roman—an antecedent of today's Foundational hand.

MS. no. 200, folio 117r. Boston Public Library Rare Book Department. Courtesy of the Trustees of the Boston Public Library.

A Color Portfolio of Calligraphy

THE ART OF CALLIGRAPHY—both hand-lettered manuscripts of the past and pieces made by calligraphers working today—is often alive with vivid color. Hoping to inspire you, I begin this book with a selection of full-color images, including both historical masterpieces as well as a few of the pieces that I myself have made.

Many "hands," or distinct lettering styles, have evolved since the sixth century. We can trace the changing characteristics of the letters of the alphabet from the Uncial hand, which dates from the sixth century, through the Carolingian hand (ninth century); the Gothic, or Black Letter, hand (14th century); and the Italic hand (15th century). In the early part of the 20th century yet another hand, known as Foundational, was introduced. The letters of this "new" hand, created with a broad-edged pen, imitate those incised in stone by ancient Roman artists.

You will learn the basics of all five of these traditional hands in this book, but the best sources for studying them are, of course, original documents. As in any artistic discipline, looking at original pieces produced by great artists gives you a kind of insight—and pleasure—that can't be gained any other way. Manuscript collections in a number of American libraries and museums—including, prominently, the Boston Public Library, the J. Paul Getty Museum in Los Angeles, the Morgan Library in New York City, the Newberry Library in Chicago, and the Walters Art Museum in Baltimore—make this type of close-up study possible.

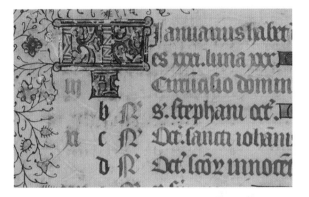

Books of hours often contain calendars of the church year. The detail shown here, from an early 15th-century French or Belgian book of hours in the Walters Art Museum's collection, is from just such a calendar. If you look closely, you can see that the first word on the page, to the right of the large decorated element at top center, is *Januarius* (January); a list of feast days follows. The colors of the initials preceding the feast days' names may indicate the relative importance of each. It was common, in such calendars, to signal the most important feast days with a red initial—which is the origin of our phrase "red-letter day."

MS. no. W281, folio 1v. Copyright: Walters Art Museum.

Of all the world's hand-lettered manuscripts, the Book of Kells is probably the most famous and is certainly one of the most important. Written in Latin, in the Uncial hand, in about the year 800, the book was created by monks belonging to a monastic community originally located on the island of Iona, off the Scottish coast. Viking raids caused the community to move to Kells, in County Meath, Ireland. Since its creation 1,200-plus years ago, the book has had a checkered history: it has been stolen and recovered several times, and it is nothing short of a miracle that this artistic treasure—now housed at the library of Trinity College, Dublin—has survived.

The Book of Kells is a Gospel book; it contains the texts of the New Testament books of Matthew, Mark, Luke, and John. Some of its pages are elaborately decorated, but I have chosen to show you this relatively simple page because it provides such a good example of the Uncial hand—and because it possesses a very interesting element. In the center of the third line of the page is an image of a peacock. Although the peacock was a symbol for Christ in early Christian iconography, the peacock image here is not just symbolic decoration. It is an instance of a technique known as *turn-in-the-path,* and is intended to guide the reader's eye. The line of text that the peacock is perched on (the fourth line) actually ends on the line above it (the third line). The peacock is instructing the reader to go up a line, rather than down, to continue reading line 3. It's unknown why the turn-in-the-path technique was used here. It may have been to correct a mistake—to insert words inadvertently dropped by the scribe who first lettered the text. It may have been a space-saving strategy to ensure that the page would be filled with text from margin to margin. Or it may just have been a playful visual game (the Book of Kells contains many visual "puzzles").

MS. no. 58, folio 309r. Reproduced by permission of the Board of Trinity College, Dublin, Ireland.

The hand used in this early 10th-century French manuscript is Carolingian—named after the Holy Roman emperor Charlemagne (Carolus Magnus, in Latin). The book from which this page comes is a lectionary (a selection of readings linked to the days of the church year) and belonged to the Benedictine abbey of St. Illidius near Clermont, in central France. Now in the rare book collection of the Boston Public Library, it may have been created in the St. Illidius abbey's scriptorium.

The vellum pages of the manuscript measure about 10 by 12 inches, making it a fairly large hand-lettered manuscript. The orange color decorating some of the letters was originally red, but the pigment has faded over time. The ink used in the lettering appears brownish, but it, too, has faded and would originally have been darker. If you study the photo carefully, you may be able to see that letters of some words are joined by thin connecting strokes. This characteristic feature of the Carolingian hand is the forerunner of the joined letters of cursive writing, which evolved much later.

Another interesting aspect of the manuscript is the damage its pages have sustained over time. If you look in the lower right-hand corner of the page shown, you'll see some dark blotches, which are holes that, long ago, were chewed through the vellum by worms or insects.

MS. no. 95, folio 37r, Boston Public Library Rare Book Department. Courtesy of the Trustees of the Boston Public Library.

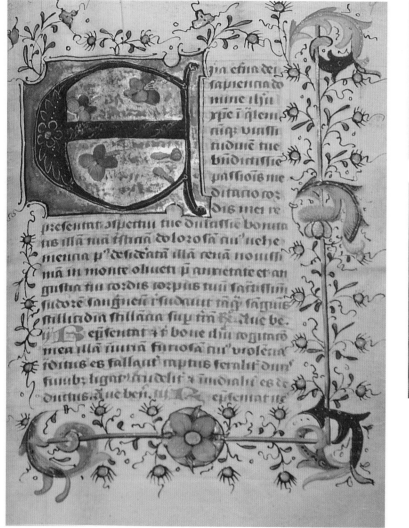

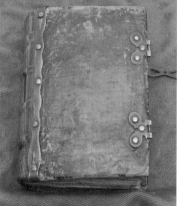

A large, extraordinarily detailed decorated initial *E* dominates the page, far left, from a prayer book produced in the Netherlands (possibly in the city of Utrecht) in 1440. The gold used in the decoration is real, 22-karat gold leaf, not metallic paint. Applying the gold leaf was a complicated procedure. First, several layers of gesso were laid down on that portion of the page to create a raised effect. Then the artist would lightly breathe onto the gesso, moistening the glue-like substance just enough to ensure that the gold leaf would stick to it when applied. Next, the artist would burnish the gold leaf by rubbing it with a polished agate or other hard stone. The burnishing not only secured the bond between the gesso and the gold leaf, but it also brought out the gold's brilliance. Decorations employing gold leaf are called *illuminations* because the shining gold "lights up" the manuscript page. The stylized floral decoration used in the margins here is an example of what is called *vine illumination*.

MS. no. 162, folio 9r, Boston Public Library Rare Book Department. Courtesy of the Trustees of the Boston Public Library.

The technique used today to apply gold leaf is very similar to that followed by artists of hundreds of years ago. The decorated *N* at top center comes from a piece that I myself made. I include it to show you just how brilliantly gold leaf shines when first applied.

The centuries-old manuscripts housed in rare book collections have often lost their original bindings. This binding—covering the 15th-century Gothic manuscript from the Netherlands shown at far left—is probably not original, but it is very old. Such bindings were typically made of leather-covered wooden boards; the book would be held shut when not in use by clasps like the brass clasps shown here.

MS. no. 162, Boston Public Library Rare Book Department. Courtesy of the Trustees of the Boston Public Library.

This magnificently colored and decorated page appears in a manuscript made in Florence, Italy, around 1460 and now in the Walters collection. Unlike the other historical examples in this portfolio, this is not a religious book; it's a biography entitled *The Life of Alphonso VI, King of Aragon and Naples (1416–1458),* by Giovanni della Casa. (You can see the author's name—or, rather, its Latin form, Ioannis de Casa—in the first line.) In this case, we also know the name of the scribe: Bartolomeo Sanvito.

The book was commissioned by the Medici family, and this page displays the Medici coat of arms—red balls on a gold shield—in the medallion at bottom center. The text is written in the Italic hand, sometimes called Humanistic Cursive by art historians.

The intricately interwoven vine decoration on this page required an extremely gifted artist. The painting is done *around* the vines, and the white of the vines is actually unpainted vellum visible within the painted areas. This piece has a surprisingly modern look—as if it were executed by an Art Nouveau designer of the early 20th century rather than a scribe of the Italian Renaissance. But that's undoubtedly because artists working in the Art Nouveau style often looked to Renaissance and other early sources for their inspiration.

MS. no. W405, folio 2r. Copyright: Walters Art Museum.

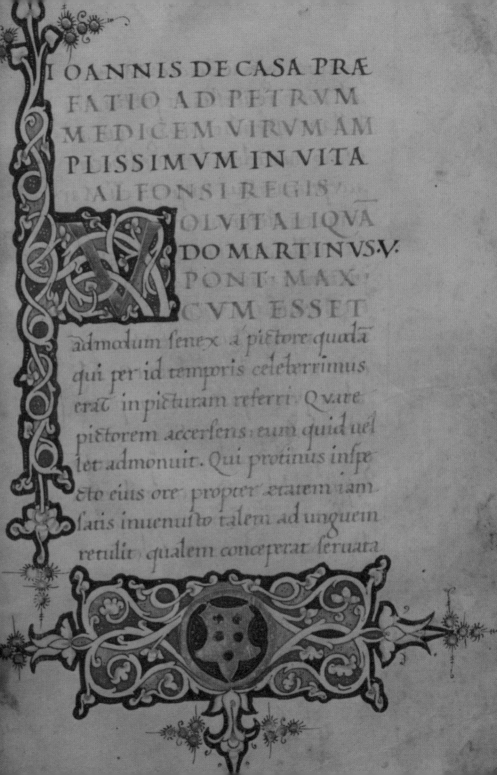

AND·IN·THAT· REGION there were shepherds out in the field, keeping watch over their flock by night. And an angel of the Lord appeared to them, and the glory of of the Lord shone around them, and they were filled with fear. And the angel said to them, "Be not afraid; for behold, I bring you good news of a great joy which will come to all people; for to you is born this day in the city of David a Savior, who is Christ the Lord. And this will be a sign for you: you will find a babe wrapped in swaddling cloths and lying in a manger." And suddenly there was with the angel a multitude of the heavenly host praising God and saying, "Glory to God in the highest, and on earth peace among men with whom he is pleased!" When the angels went away from them into heaven, the shepherds said to one another, "Let us go over to Bethlehem and see this thing that has happened, which the Lord has made known to us. And they went with haste, and found Mary and Joseph, and the babe lying in a manger. And when they saw it they made known the saying which had been told them concerning this child; and all who heard it wondered at what the shepherds told them. But Mary kept all these things, pondering them in her heart.

Luke 2:8-19 *my 2002*

It's with a great deal of humility that I offer some samples of my own work in this color portfolio. I do so because I want to show you how present-day calligraphers like myself continue to make use of some time-honored techniques when designing, lettering, and decorating their pieces—while also performing some creative variations on the lettering styles and design strategies used by calligraphers of the past.

The hand-lettered excerpt from the familiar Christmas story at far left (Luke 2:8-19) is a display piece, meant to be matted and framed. For the text lettering, I created a unique style that combines characteristics of both the Italic and Gothic hands. (The basic form of the letters is Italic, but they also resemble Gothic letters in being straight up and down rather than slanted.) The gold in the large decorated *R* is gold leaf; the red versal capitals scattered through the text are embellished with both gold leaf and (outlining the letters) gold metallic paint. The red, blue, green, and white paints used in the piece are gouache, an opaque watercolor.

This detail at left, from another display piece I did (the text is from Ecclesiastes), shows how gouache painting can enhance a hand-lettered document. Not only are the versal capitals decorated in gold leaf and gouache, but the piece incorporates a small, decorative image of a lily, also rendered in gouache.

When using color in a piece, it's important to steer clear of colored inks, which can fade very quickly if exposed to sunlight. Gouache is a much more successful medium. If gouache is used for lettering, however, it must first be thinned with distilled water so that it flows easily through the pen's nib (but not thinned so much that it puddles on the vellum or art paper).

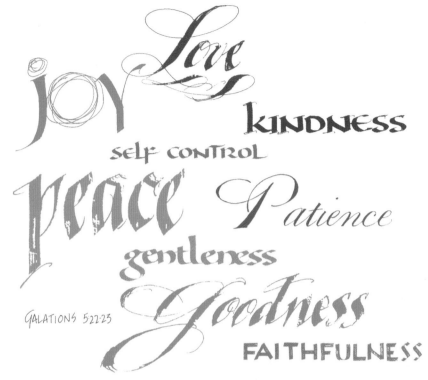

Love

joy

kindness

self control

peace

Patience

gentleness

Goodness

FAITHFULNESS

GALATIONS 5:22-23

May the Fruits of the Spirit
be yours throughout
this holiday season & always

The Abbey Studio

Many works of calligraphy are rather formal (or very formal) in nature, as befits their subject matter. But calligraphy can also be informal and playful—which was the effect I was aiming at in this holiday card, which I sent to friends and clients of my business, The Abbey Studio, several years back. Although its message is a serious one, this greeting was also meant to be cheerful, and to that end I used a very diverse selection of lettering styles—some traditional, some very modern—and a range of bright colors.

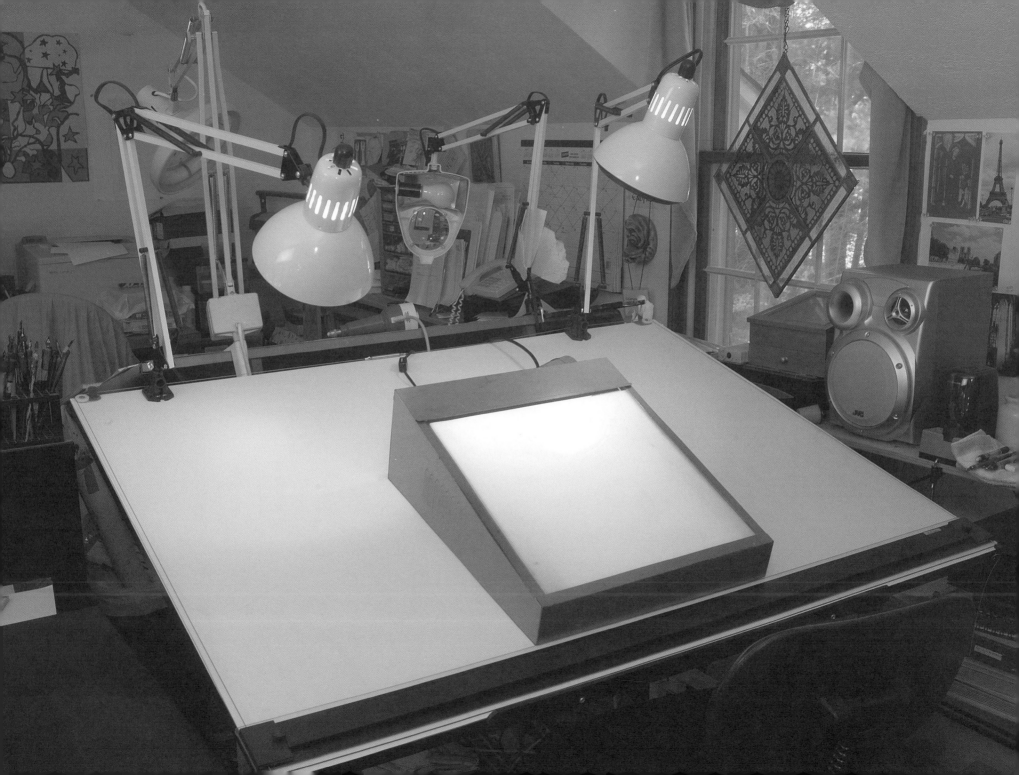

Using This Book

THE FIRST THING YOU NOTICED about this book was probably its unusual design. You turn the pages by flipping them up, not by turning them from right to left. This format, and the spiral wire binding (which ensures that the book lies flat when opened), allow you to work directly on the book's worksheets wherever indicated: You simply place a sheet of tracing vellum on top of the worksheet, secure it to the book page with drafting tape (not masking tape), and trace. By tracing the strokes and letters, you will quickly get a feel for them—an excellent method, I think, for learning the letters' shapes and how to form them.

The book also contains a feature that's unique among calligraphy workbooks. At the back, you'll find five transparent Guide Sheets. Though the sheets are bound into the book, they're perforated for easy removal. These Guide Sheets are very much like the ones I've designed for students taking the calligraphy classes I teach. You'll learn how to use them as you progress through the exercises in the book.

The book is divided into eight chapters. The first familiarizes you with the supplies you'll need for both beginning and more advanced work, as well as introducing you to the terminology used throughout the book and to the basic components of broad-edged pen lettering. It contains a great deal of information, and you should refer back to it frequently throughout the course.

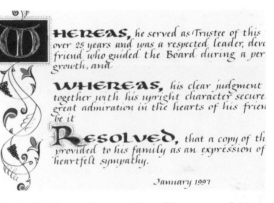

This detail is from a "memorial scroll"—a type of document that companies sometimes present to the family of a deceased board member or other officer. Such scrolls (which though referred to as scrolls are actually flat, frameable pieces) often contain excerpts from the minutes of the board meeting at which the late officer's contributions to the firm are cited.

The scroll's decoration is a combination of gold leaf, gold metallic paint, and gouache. The document is lettered in several different styles to heighten visual interest through contrast.

Chapter 2 introduces the Italic lettering style, or *hand,* as calligraphers refer to any hand-lettered alphabet. The other major hands—Uncial (and Half Uncial), Carolingian, Gothic (Black Letter), and Foundational (Roman)—are introduced in chapters 3 through 6. I estimate that each of these chapters contains about two hours' worth of work, and I suggest that you break up each chapter into two one-hour sessions, giving yourself at least a 15-minute break between sessions. As with any skill, lettering requires practice—lots of it. Your proficiency in lettering with a broad-edged pen will be determined more by your dedication to practice than by any inherent talent you may possess. I strongly urge you to practice frequently and regularly, making it part of your daily routine.

Chapter 7, "Design Tools," acquaints you with some of the tools that professional calligraphers use in creating original works. And the book's last chapter, chapter 8, introduces you to basic layout techniques and encourages you to make use of all you've learned throughout the "course" by suggesting five special projects for you to try. These should be done with the help of the transparent Guide Sheets at the back of the book. (You can also use these sheets for calligraphy projects that you create yourself.)

The Guide Sheets, as well as all the worksheets throughout the book—the basic strokes, alphabet sheets, and so on—are designed for use with a broad-edged pen whose nib measures 2 millimeters (2mm) across. To emphasize calligraphy's hand-crafted quality, the strokes and alphabets on the worksheets are reproduced just as I lettered them, without retouching.

As you work your way through the various alphabets, you will quickly notice that each has a different proportion. Some alphabets appear tall and slender, while others look short and squat. All the letters on this book's worksheets (except for the enlarged samples) have been made with the same pen, and all the differences in appearance are due to changes in the *pen scale*—an important term explained and illustrated in the terminology section of chapter 1. Only a clear understanding of lettering techniques will lead to professional-quality results, so please take the time to familiarize yourself with the terms and descriptions in chapter 1 before getting started with the pen.

In this book, my intention is to teach you the "classic" form of each alphabet made with the broad-edged pen. After you've achieved a level of competence with the classic lettering styles, I encourage you to experiment—for instance, with changes in pen scale or by adding serifs and flourishes (chapter 2) to make each alphabet your own creation.

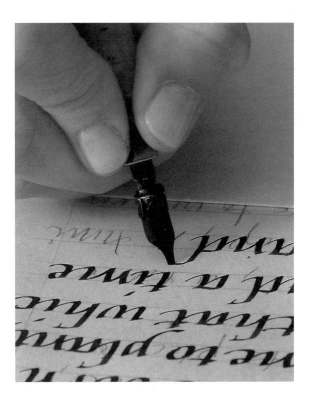

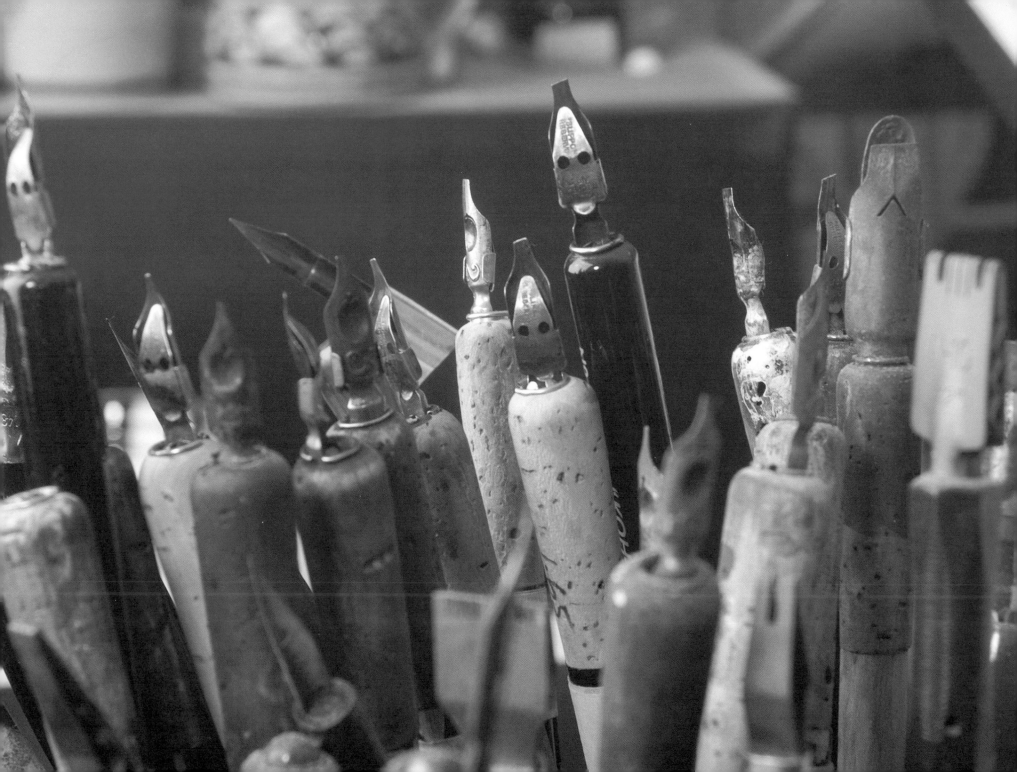

Getting Started

THE ROOM IN WHICH YOU WORK is especially important. It should be comfortable and well lit, with plenty of space for you to set up. You should work on a sloped work surface positioned at an angle of about 30 degrees, so a drafting table is necessary. To begin with, a portable, tabletop-style drafting board will do, but if you become serious about pursuing calligraphy, you will be wise to invest in a professional, stand-alone drafting table.

Assuming you're right-handed, place your writing materials (pencils, pens, and ink) and other supplies on a table to your right. The photo at right shows my own workspace—crowded with tools of the trade, but tidy and ready for a work session.

Proper lighting is essential to a comfortable work environment. Clip-on drafting lamps, such as Luxo DB clamps (about $25), provide a good level of illumination for relatively little money.

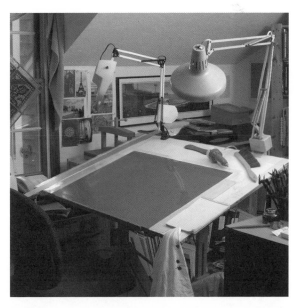

Though my own studio is crowded with reference books, an array of pens, and other tools of the trade, I keep the drafting table neat—always ready for the next work session.

So that your lettering remains consistent, be sure to keep your work directly in front of you, and work with the paper positioned straight up and down. (The way many of us normally write—with the paper tilted at an angle—makes lettering more difficult.)

You should place a hand blotter under your hand as you write, as shown in the photo at right. A hand blotter—which you can buy from an art supplies store or make yourself by cutting a 11" X 4" rectangle from a larger sheet of blotter paper—will prevent oils from your hand from being absorbed by the art paper you're working on. If oils from your hand do penetrate the paper, the ink will be repelled from the paper and your letter shapes won't form correctly.

Keep a rag or cloth nearby for cleaning up drips, and have a piece of scrap paper handy for testing ink flow. New pens, especially, can be temperamental—they can feel scratchy and resist ink flow until they have been used for a little while. Before you begin writing on your tracing vellum or art paper, use the scrap paper to get the ink flowing and to remove the drop of ink that may have accumulated on the nib.

– 22 –

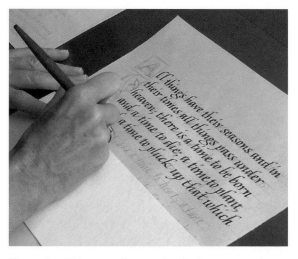

Place a hand blotter under your hand whenever you letter.

Supplies

Because there are some supplies you'll need immediately and others you may choose to buy later, as you do more advanced work, I've divided the supplies into two lists. The first list comprises all the supplies necessary for learning basic broad-edged pen lettering; the second list includes some of the other tools you may want when you begin to do projects involving the use of color and graphic design.

Calligraphy supplies can be difficult to find. Your best bet for finding a good assortment is a local art supply store (though craft stores sometimes carry some of these supplies) or the Internet. Two good mail-order calligraphy supplies companies are Paper & Ink Arts (www.paperinkarts.com) and John Neal Bookseller (www.johnnealbooks.com).

Basic Supplies

Obviously, pens are a calligrapher's most important tools. The next section of this chapter discusses the broad-edged pen in detail, but before beginning, you should purchase a set of calligraphy fountain pens (*not* markers) and an assortment of dip-pen nibs of various sizes as well as one pen holder for each nib.

I prefer using dip pens for calligraphy because the results are better and the range of supplies is broader. Fountain pens, however, are less messy (the cartridges eliminate the need for bottled ink), and beginners may find them easier to work with. If you do begin your study of calligraphy with fountain pens, I urge you to switch over to dip pens once you've gained a little experience with broad-edged pen lettering.

Most dip pens require a reservoir (see the photo at right), so be sure to purchase reservoirs. (Pens made by some manufacturers—Speedball and Brause, to name two—come with reservoirs attached.) To use the worksheets in this book, you'll need a pen with a nib measuring 2mm across, so make sure the pens you buy include at least one with this nib width. In most fountain pen sets, the 2mm pen is marked *B,* for "broad." If you are left-handed, be sure to purchase left-handed pens (on which the oblique cut of the nib is reversed).

The photo at the bottom of the next page shows most of the basic supplies you'll need. Here's a complete list:

- Ink. Choose Higgins Eternal permanent black ink or a similar bottled black ink, such as Dr. Martin's or Pelikan 4001. Do *not* buy India ink or any ink containing lacquer, because it will corrode your pens.

- A drafting board. A portable, tabletop model is perfectly acceptable at this point.

- A pad of high-quality tracing vellum. (My favorite is the 9" X 12" vellum pad made by Canson.) Do not attempt to use ordinary tracing paper, which is too porous for calligraphy inks.

- At least two no. 1 (extra-soft) pencils.

- A mechanical pencil with 0.5 lead (HB). This hard lead will produce a light line appropriate for drawing writing guidelines, which will later be erased.

- A pad of smooth-surfaced calligraphy paper, such as Paris Paper for Pens (9" X 12") or Diploma Parchment (8" X 11").

- A hand blotter.

- A roll of ¾-inch drafting tape. (I use Scotch drafting tape.)

- A plastic eraser (such as the Staedtler Mars Plastic).

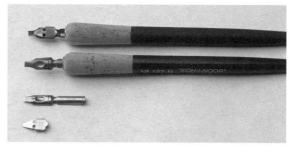

Some dip-pen holders have cork grips. The one at the top has the nib and reservoir in place. The pen just below has been turned over to show the nib. Below the assembled pens are a detached nib and reservoir.

- An 18-inch or larger T square. A high-quality acrylic triangle is a reasonable substitute at first, but a T square is preferable. (For more on T squares versus triangles, see chapter 7.)

- An assortment of art papers. With experience, you'll determine whether you prefer smooth-surfaced or "toothy"-surfaced papers, but for starters try an assortment of papers by Arches, Canson, Fabriano, or Lana. Paper & Ink Arts sells a Fine Paper Sampler, which enables you to experiment with several different high-quality papers.

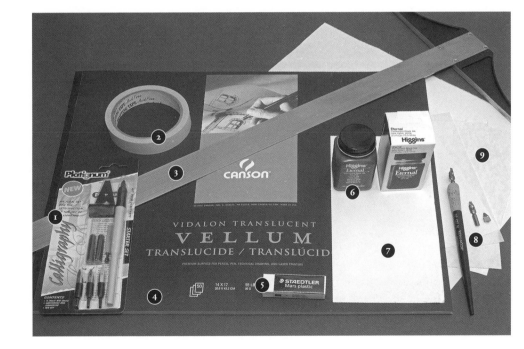

The basic supplies you'll need include (1) a set of calligraphy fountain pens; (2) a roll of ¾" drafting tape; (3) a T square; (4) a pad of tracing vellum; (5) a plastic eraser, (6) a bottle of permanent black ink; (7) a hand blotter; (8) a dip-pen holder, with 2mm nib and reservoir; and (9) a selection of art papers.

Advanced Supplies

The following list of supplies for the more advanced calligrapher—many of which also appear in the photo at the bottom of the next page—is necessarily incomplete. For calligraphy, as for any art, many different kinds of supplies are available. As your work improves and you experiment with various kinds of projects, you'll want to try new tools and techniques—and to let your imagination take flight.

- An assortment of tubes of designer's gouaches (opaque watercolors). (I prefer Winsor & Newton Designers Gouaches.)

- Gold and silver metallic paints, such as Winsor & Newton's Designers Gouache gold and silver. (These come in bottles, not tubes; some brands of metallic paints come in little cakes, called *pans*.)

- Distilled water, for thinning the paints.

- Inexpensive brushes for mixing paints.

- Porcelain mixing dishes.

- A light box—or a drafting table with a Plexiglas surface and light-box capability.

- Drafting tools (technical pens, compass, triangle, protractor).

- A centering ruler. On a centering ruler, the zero appears in the center; distance from the center is marked off, in inches, to both the left and the right.

- A 15- or 18-inch cork-backed steel ruler. On good steel rulers, the measurement lines begin a quarter-inch or so from the ruler's end to ensure accurate measuring. The cork backing raises the ruler off the paper slightly, which, among other things, helps keep the paper clean and free of smudges.

- A good paper cutter.

- An X-Acto knife (no. 11 blade).

- An electric eraser.

- Sandarac. This is an organic substance that is ground to a fine powder and then put in a pouch of loosely woven fabric; when the pouch is dusted across the paper's surface, the fine granules of sandarac that fall out act as a resist, preventing oils from being absorbed by the paper.

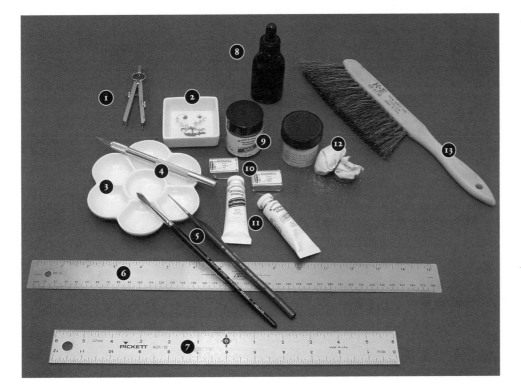

Among the supplies you may want to purchase as your expertise in calligraphy grows are (1) a compass (and perhaps other drafting supplies, as well); (2) and (3) porcelain mixing dishes, for paints; (4) an X-Acto knife; (5) inexpensive paint brushes; (6) a cork-backed steel ruler; (7) a centering ruler; (8) an eye-dropper bottle (for distilled water); (9) and (10) metallic paints (available in both bottled and "pan" form); (11) designer's gouaches; (12) sandarac; and (13) a drafting brush, for brushing away erasures. Note that sandarac (item 12) is sold in small jars; it must be transferred to a fabric pouch, like the one shown, to dust art paper.

Using a Broad-Edged Pen

Calligraphy pens—both fountain pens and dip pens—are broad-edged pens. Unlike the point of a ballpoint pen or a marker, the chisel-shaped nib of a broad-edged pen allows the user to create strokes of varying width, depending on the angle at which the pen is held and the direction in which the stroke is made.

The part of the pen that touches the paper—the part that actually does the writing—is called the nib. Most nibs have a slit down the middle, which allows the user to make an even wider stroke by applying pressure during writing.

Fountain pens have their own ink supply, in the form of an ink cartridge that fits into the pen holder. The longevity of a cartridge will vary according to how often the pen is used, but you can expect a cartridge to last about a month once it is attached to the nib. (Note that the ink in a cartridge will dry out if the pen is not used regularly.) By contrast—and as their name implies—dip pens do not have their own ink source and must be dipped again and again into the ink as you work.

Most dip pens require the use of a reservoir, which retains a small supply of ink while you write, and these reservoirs are usually sold separately. So when purchasing a dip pen you must buy three parts: the nib, the reservoir, and the holder. After you've placed the nib in the holder, you must fit the reservoir onto the bottom of the nib, making sure that the reservoir hugs the nib tightly enough that it doesn't slide around—but loosely enough that it doesn't cause the nib to split open. The photo at right provides a close-up view of dip-pen holders, with nibs and reservoirs attached and disassembled.

– 28 –

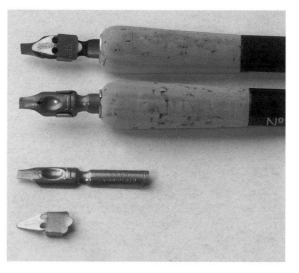

This close-up view shows how the nib and reservoir should look when attached to the holder (top). Below are the nib and reservoir as they appear before the pen is assembled.

Characteristics of Letters

Each lettering style, or hand, that is made with the broad-edged pen has certain characteristics that remain constant within that hand and, in fact, actually define the particular hand. These defining characteristics are pen angle, pen scale, and letter slope. As you work through this book, you will see that the first pieces of information I give when introducing a lettering style are its pen angle, pen scale, and letter slope. Once you have an understanding of these characteristics, you will be able to create limitless, professional-looking variations on each style (the Italic, the Carolingian, and so on) by altering these three variables.

As you do this, you will find that maintaining consistency is essential. For example, the traditional Italic alphabet is made with a 45-degree pen angle, a five nib-width x-height (a term we'll define in a moment), and a letter slope of 4 degrees. If you want to create a variation on that classic proportion using a 50-degree pen angle and a 0-degree (perfectly vertical) letter slope, you certainly can. But for the results to look professional, you'll have to make those changes consistently throughout the entire piece. Herein lies the art of calligraphy: perfecting your lettering skills so that you will have consistent pen angle, pen scale, and letter slope even when creating letters that are no longer strictly traditional in their design. Now, let's take a closer look at each of these characteristics.

PEN ANGLE

Pen angle is the angle at which the pen's nib is held in relation to the writing line, or baseline. In the drawing at right, the pen angle is 45 degrees. The section entitled "Handling the Pen," following, presents information on determining pen angle and exercises designed to help you maintain a consistent pen angle as you letter.

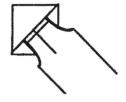

Pen angle is the angle at which the nib is held in relation to the writing line—in this case, 45 degrees.

PEN SCALE

Pen scale (also known as letter proportion) is what gives letters their character-istic appearance—tall and slender or short and squat. The pen-scale proportion is determined by two variables: the width of the pen's nib and the number of times the nib, placed sideways, will fit into the x-height.

NIB WIDTH

As shown in the drawing at top right, nib width is the width of that part of the nib that touches the paper—the edge from which the ink flows and that makes the stroke. All the alphabets in this book have been made with a nib that measures 2mm across, and all the guide sheets have been designed to accommodate a pen with a nib width of 2mm.

X-HEIGHT

X-height (pronounced *ex*-height) is the height of a lowercase letter from the baseline to the top of the letter's main body. (X-height excludes ascenders and descenders, the strokes that extend above and below the letter's body, as in the letters *d* and *g*.) In this book's worksheets, the x-height is the space between the solid horizontal lines, as shown in the drawing at center right.

Looking at the samples in the drawing at bottom right, you can see that the same x-height was used for all four groups of letters, but the nib width has changed. As a result, the pen scale, or letter proportion, varies from one sample to another.

The nib width is indicated by the bracket in this simplified depiction of a pen nib.

The solid horizontal lines mark off the letters' x-height.

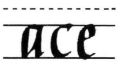

The pen scale of the sample at left is the classic letter proportion for the Italic hand. The two samples in the middle have the same x-height but were lettered with narrower nibs. For the sample at right, the same x-height was again retained, but a wider nib was used.

Calligraphers commonly use a "checkerboard" pattern—made with the nib of the pen—to determine x-height. For example, in the classic letter proportion for the Italic hand, the x-height is five nib widths, as can clearly be seen in the drawing at top right.

The checkerboard patterns shown in the next drawing, bottom right, demonstrate how nib width is used to establish x-height. Note that the stroke you make with the nib is actually a little wider than the measurement of the nib itself. This happens because of the slit that runs down the center of the nib: the nib spreads apart when pressure is applied, resulting in the slightly wider stroke. For this reason, it is more accurate to establish x-height with a checkerboard than simply by measuring the nib width and multiplying that measurement.

It's easy to make your own checkerboards. To make a checkerboard, start with a straight, vertical pencil line. Place your nib against the pencil line and make a short stroke, applying enough pressure to get the full measure of the nib width and drawing the stroke directly away from the vertical line so that the stroke is perpendicular to the pencil line. Now rotate the paper 180 degrees and make another short stroke, right next to the first one but going away from the pencil line in the opposite direction. Continue rotating the paper and making strokes on opposite sides of the pencil line until you have made a checkerboard consisting of 15 strokes. This will provide you with the measurements necessary to make a 5 nib-width x-height and 5 nib-width areas for ascenders and descenders.

After you've completed the checkerboard and allowed the ink to dry, label your ruler with a title, such as "X-Height for Italic, No. 2 Mitchell Roundhand Nib," and retain it in your files. You can transfer the measurements from the checkerboard to a sheet of art paper by creating a paper ruler, as described in chapter 7.

The Italic hand's classic letter proportion is five nib widths, as the checkerboard pattern at right shows.

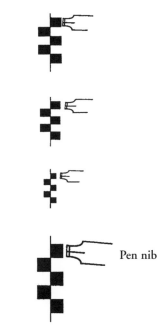

Pen nib

The size of a checkerboard varies according to the width of the nib you use.

LETTER SLOPE

Letter slope, or slant, is another important element in calligraphy. The term refers to the angle of a letter's slope (or slant) in relation to an unseen vertical (or 0-degree) line perpendicular to the baseline. The sample in the drawing at top right shows a letter slope of 4 degrees. In the worksheets of this book, the slope is represented by the lines that intersect the baseline, sometimes at a diagonal and sometimes vertically (where the letter slope is 0 degrees).

ASCENDERS AND DESCENDERS

As mentioned above, ascenders and descenders—shown in the drawings at bottom right—are the parts of a lowercase letter that extend above and below the x-height. The worksheets in this book contain guidelines for the ascenders and descenders in each lowercase alphabet.

– 32 –

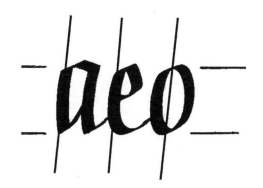

The diagonal lines intersecting the writing line indicate letter slope.

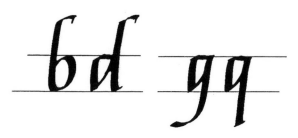

Letters such as *b* and *d* have ascenders; letters such as *g* and *q* have descenders.

Handling the Pen

As you begin, it's very important to familiarize yourself with the way a broad-edged pen works and to understand its effect on letter shapes. Here are a few exercises you can work through that will help you become comfortable with the tool that defines calligraphy.

The Double-Pencil Technique

Using a rubber band, secure two well-sharpened pencils together so that their points are even with one another. Imagine a line running between the two pencil points; this imaginary line is equivalent to the writing edge of a pen's nib. The drawing at top right shows the correspondence.

By drawing some letters with the two pencil points, you will begin to see how the broad-edged pen works to create the characteristic "thicks and thins" of calligraphy, as shown in the next two drawings.

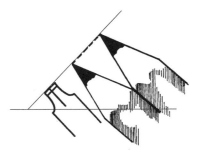

For this double-pencil exercise, think of the imaginary line between the two pencil points as the writing edge of a pen's nib. The "pen angle" in this drawing is 45 degrees.

The double-pencil technique reproduces the characteristic "thicks and thins" of a broad-edged pen. Pen angle and stroke direction determine where the thicker and thinner parts of the letter appear. The diagonal broken line through the letter *o*, at left, is the axis of the thin part of the stroke as created by a 45-degree pen angle.

When formed using a 0-degree pen angle, the axis of the letter *o* is vertical.

Determining Pen Angle

Remember that when we talk about pen angle, we are referring to the relationship between the pen's nib and the baseline, or writing line. For the alphabets in this book, we will use four pen angles: 20 degrees, 30 degrees, 40 degrees, and 45 degrees. The illustrations at right show how to use a protractor to determine the pen angle—and the strokes that result when the pen is held at two different angles.

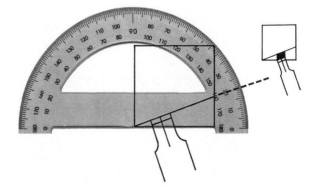

A protractor can be used to determine pen angle. Above, the pen angle is 20 degrees; below, the angle has been increased to 45 degrees.

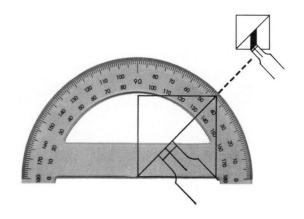

Once you have determined that your pen is being held at the correct angle, it is crucial to maintain that hand position as you write. When you write with a ballpoint pen, rotating your wrist has little or no impact on the letter shapes. Just the opposite is true when using a broad-edged pen. Each time you change wrist position, you change the pen angle, so it is very important *not* to rotate your wrist while lettering. The movement should come entirely from your fingers, with the wrist held very stiffly even when you lift the pen from the paper or vellum. The photo at right shows the proper way to hold a pen when lettering.

Determining the Pen Angle of an Existing Letter

Knowing how to determine the pen angle of an existing letter can be very useful. When you become more familiar with calligraphy, you will see alphabets that you admire and wish to duplicate in your own hand. Determining the pen angle, letter slope, and x-height of an existing letter (or alphabet) will help you re-create that alphabet yourself. The drawing below shows you how to determine a letter's pen angle.

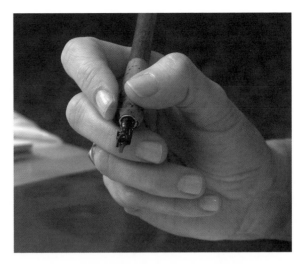

Once you've determined the correct pen angle, keep your wrist stiffly in place while lettering. The angle of the holder (the pen's "handle") is not too important; what *is* important is the angle of the nib in relation to the writing line. The photo shows the pen being held at a pen angle of 45 degrees, which is maintained even when the pen is lifted from the writing surface.

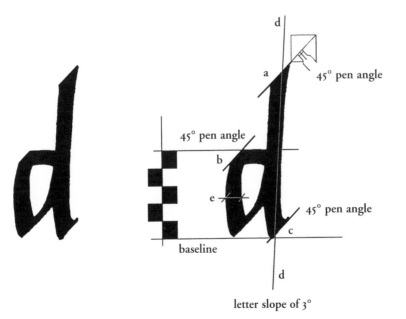

letter slope of 3°

It is possible to determine the pen angle, letter slope, and proportion of an existing letter—like the *d* reproduced at right—by following these steps. First, draw a line along any of the exposed edges where a stroke begins or ends (points *a*, *b*, or *c*); using a protractor, you can determine the angle of that line (in this case, 45 degrees). A line drawn parallel to the edge of any non-curved downward stroke (line *d*) will show the letter slope (here, 3 degrees). By measuring the width of a downward stroke (point *e*) and establishing how many times that measurement fits into the x-height, you can determine the letter proportion (here, 5 nib widths).

Spacing

Letter spacing affects legibility and contributes to a hand-lettered document's overall design and appearance. Spacing between letters is a matter of visual consistency rather than mathematical accuracy. It is largely a discretionary design element, so there are no hard and fast rules. There are, however, some general guidelines that can be followed when planning and executing your calligraphy, as the drawings at right illustrate. As they also show, the tightness or looseness of the letter spacing can even lend a certain emotional quality or tone to a piece of calligraphy.

Line spacing also sends visual cues. For instance, the lines of text in a formal piece, such as a wedding invitation, will usually be widely spaced. Text that is tightly stacked, with very little space between the lines, can heighten the drama or importance of a message, as in Christmas card below. Body text is usually moderately spaced.

Tightly stacked lines can carry a visual punch, as on this Christmas card.

Tight spacing can make a piece appear serious, forceful, and formal.

Loose spacing gives the impression of a more casual, free-flowing attitude.

There are even instances where overlapping letters can be effective.

tall

Typically, the widest letter spacing occurs between two upright letters with no curve.

told

The space between an upright letter and a curved letter is narrower than that between two upright letters.

took

Two curved letters next to one another will have the least amount of space between them.

Using the Worksheets

Before we move on to the next chapter, in which you'll begin working with the broad-edged pen, let's take a moment to examine the worksheets that are such an important part of this book.

In each of the chapters dealing with a particular hand—Italic, Uncial and Half Uncial, Carolingian, Gothic, and Foundational—the first worksheet you encounter acquaints you with the *skeletal letter shapes* of that alphabet. Work on this worksheet is to be done in pencil. The other worksheets are designed for use with pen with a nib measuring 2mm across. The illustration below shows the basic components of each worksheet.

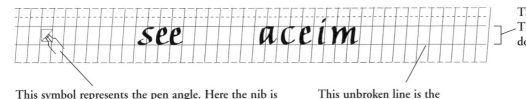

The area between the solid horizontal lines is the x-height. The body of each letter (excluding any ascender and descender) should fill this space, as shown.

This symbol represents the pen angle. Here the nib is held at a 45-degree angle in relation to the writing line.

This unbroken line is the writing line, or baseline.

The broken lines with longer dashes indicate where the ascenders and descenders should end, as shown.

Some worksheets have two rows of broken lines above the x-height. This is because the uppercase, or capital, letters of some alphabets are shorter than the ascenders of the lowercase alphabet.

The diagonal lines represent the letter slope (in this case 4 degrees; on worksheets for alphabets with a 0-degree letter slope, these lines are vertical). They are intended to guide the slant (or verticality) of your letters.

The checkerboard shows the x-height and the areas for ascenders and descenders as measured by nib width. This method can be used for any broad-edged pen of any width.

That
which gives light
must endure burning

Viktor Frankl

The Italic Hand

THE ITALIC LETTERING STYLE DEVELOPED IN ITALY during the 15th century. The comparatively sharply angled slope and joined letters characteristic of the Italic hand resulted from the need for a faster method of writing. Italic is the predecessor of the joined, cursive style of handwriting taught today in elementary schools. It is a lovely, graceful hand and is probably the most commonly used calligraphic style.

We study this lettering style first because it is the hand most people visualize in their minds when they think of calligraphy. Once we have thoroughly studied the Italic hand and its characteristics, it will be easier to go on to a chronological study of the other major broad-edged lettering styles.

Italic Skeletal Letter Shapes

The Italic Skeletal Letter Shapes worksheet below, like the first worksheet in each of the chapters that follow, is designed to familiarize you with the basic, or skeletal, shapes of the letters of this hand. I use the term *skeletal shapes* to refer to letters made without a broad-edged pen. Studying the skeletal shapes, your eye is not distracted by the thick and thin strokes the pen creates, and this helps you understand the actual letter shapes you will try to achieve.

To use the worksheet, place a sheet of tracing vellum on top of the page below and secure the vellum in position using drafting tape. With a pencil, carefully trace each of the skeletal shapes, paying close attention to the direction and sequence in which the strokes are made (indicated by the arrows and numbers). Make sure each skeletal shape fills the x-height completely and that the ascenders and descenders reach the indicated guidelines.

Make sure you also pay attention to the "negative space" inside the letter. If you've ever studied drawing, you'll remember being taught to look at the negative space of an object in order to more clearly see the shape that you are trying to re-create on paper. The same is true in calligraphy, although calligraphers use the term *counter* to refer to this negative space. So as you create the skeletal letter shapes, be aware of the counters—the white spaces inside the letters—as well as the shapes of the letters themselves.

To get completely comfortable with the letters' shapes, work through this exercise several times before proceeding to the next worksheet. Use moderate pressure; in other words, be firm when you make the stroke, but try not to scar the vellum.

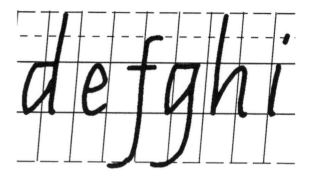

Use a pencil and drafting vellum to trace the skeletal letter shapes. This will familiarize you with the shapes of the letters without the distraction of the thicks and thins that are created with the broad-edged pen.

Italic Skeletal Letter Shapes Worksheet

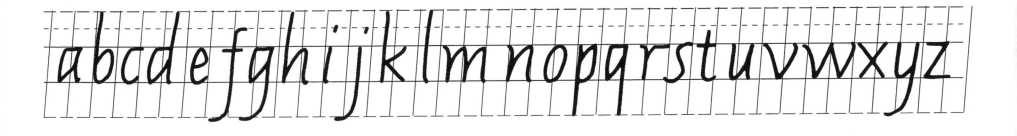

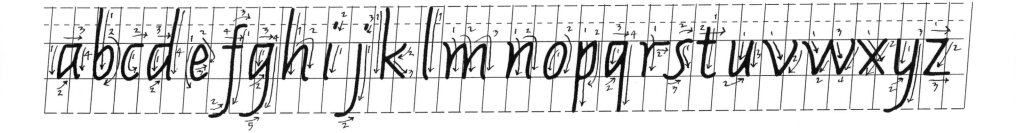

Italic Basic Strokes

Now that you've worked through the Italic skeletal shapes a couple of times, you're ready to move on to the Basic Strokes worksheet, below. For this, you will use your broad-edged pen. Choose a nib that measures 2mm across (in calligraphy fountain pen sets, this will probably be the broadest nib of the set). Tape a sheet of tracing vellum on top of the worksheet, and begin tracing the basic strokes.

The entire minuscule Italic alphabet can be made with 29 strokes arranged in various combinations. All the strokes except those numbered 26, 27, and 28 are made holding the pen at a 45-degree angle. Strokes 26, 27, and 28 are made at a flatter angle—about 30 degrees—because these diagonal strokes would be too narrow if made with a pen angle of 45 degrees. When tracing the strokes, pay careful attention to the direction in which the strokes are made (indicated by the arrows), the height of the strokes (where they begin and end in relation to the guidelines), and the thickness of the strokes. Be consistent in the amount of pressure you apply: uneven pressure will create a stroke with jagged edges.

The characteristics of the Italic hand are as follows:

Pen Angle:	45°
Pen Scale:	5 nib widths for x-height (shown between solid lines on worksheet)
	5 nib widths for ascenders (shown as longer dashed lines on worksheet), which will make the ascenders taller than the uppercase letters
	5 nib widths for descenders (shown as longer dashed lines on worksheet)
	7½ nib widths for uppercase letters (shown as shorter dashed lines on worksheet)
Letter Slope:	4°

Italic Basic Strokes Worksheet

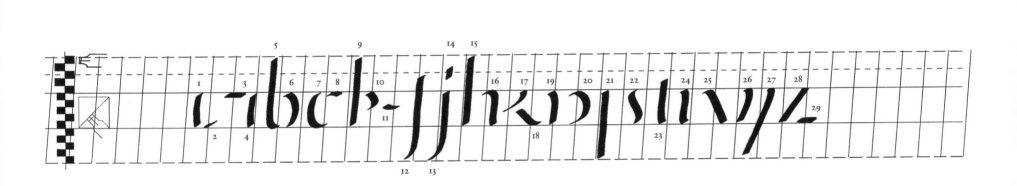

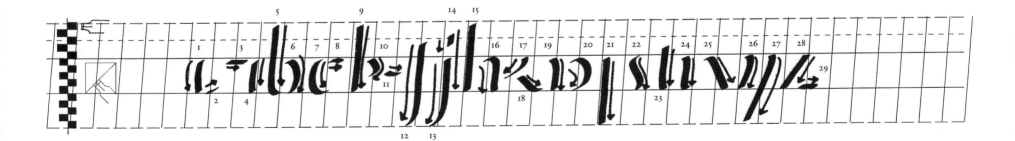

Lowercase (Minuscule) Italic Alphabet

Lowercase and *uppercase* are old typesetting terms that originally referred to the cases where type blocks for the small and capital letters were stored. Historically, small (lowercase) letters were known as *minuscules* and capital (uppercase) letters were known as *majuscules,* and these terms continue to be used by calligraphers.

Before beginning work on the Italic Lowercase (Minuscule) Alphabet worksheet below, take a careful look at it, studying the way each of the letters is made. Place a sheet of tracing vellum on top of the worksheet and secure it in place with drafting tape. Using your pen, trace the letter shapes onto the vellum. After you have traced the alphabet a few times, you will be ready to move on to the guide sheet. Remove the Italic Guide Sheet from the back of the book and, using drafting tape, secure it to the surface of your drafting table or board. Place a sheet of tracing vellum on top of the guide sheet, also securing it with drafting tape (refer to the photo on page 96 for setup) and begin creating the letters on your own, without tracing.

Keep this book close at hand and open to this page as you write out the lowercase Italic alphabet. Be patient and don't be discouraged if your first attempts do not produce the desired letter shapes. With practice your lettering will improve.

This worksheet requires a pen nib measuring 2mm across. The letters have the following characteristics:

The worksheet shows each completed letter, followed by a "blown apart" letter showing individual strokes and the stroke sequence.

Pen Angle:	45° except for certain strokes in the letters *v, w, x, y,* and *z.* (As shown on the worksheet, these are the diagonal strokes that go from the upper right to the lower left, which are made with a flatter pen angle, about 30°.)
Pen Scale:	5 nib widths for x-height
	5 nib widths for ascenders
	5 nib widths for descenders (Notice, though, that the height of the *t* is slightly lower than the broken line and that the top of the *f* as well as the dots on the *i* and the *j* extend to the broken line.)
Letter Slope:	4°

Italic Lowercase (Minuscule) Alphabet Worksheet

Notice that height of the *t* is slightly lower than broken line.

Notice that diagonal strokes going from upper right to lower left are made with a flatter pen angle, about 30°.

Uppercase (Majuscule) Italic Alphabet

Now, again using the Italic Guide Sheet and a sheet of tracing vellum, try your hand at the uppercase Italic letters on the worksheet below. (Because the uppercase Italic letters are relatively large, two worksheets are required for this alphabet. This worksheet includes the letters *A* through *Q*; *R* through *Z* appear on the following worksheet.)

Again, practice will improve your results. Calligraphy requires a great deal of hand-eye coordination, and it takes time for this skill to develop.

This worksheet is also designed for use with a pen nib measuring 2mm across. The height of a majuscule, or uppercase, letter is called the *cap height*; note that the cap height of Italic majuscules is 7½ nib widths (indicated by the broken line), which is shorter than the ascenders of the lowercase letters. Complete characteristics are as follows:

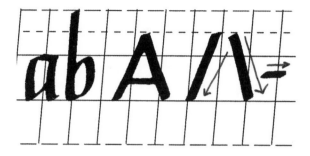

Lowercase letters appear at the beginning of this worksheet to show relative heights of ascenders and capitals. Each completed capital is followed by a "blown apart" letter showing individual strokes and stroke sequence.

Pen Angle:	45° (except for diagonal strokes in letters *A, K, M, V, W, X, Y,* and *Z,* which require a flatter pen angle, of about 30°)
Pen Scale:	7½ nib widths for cap height
Letter Slope:	4°

Italic Uppercase (Majuscule) Alphabet Worksheet 1

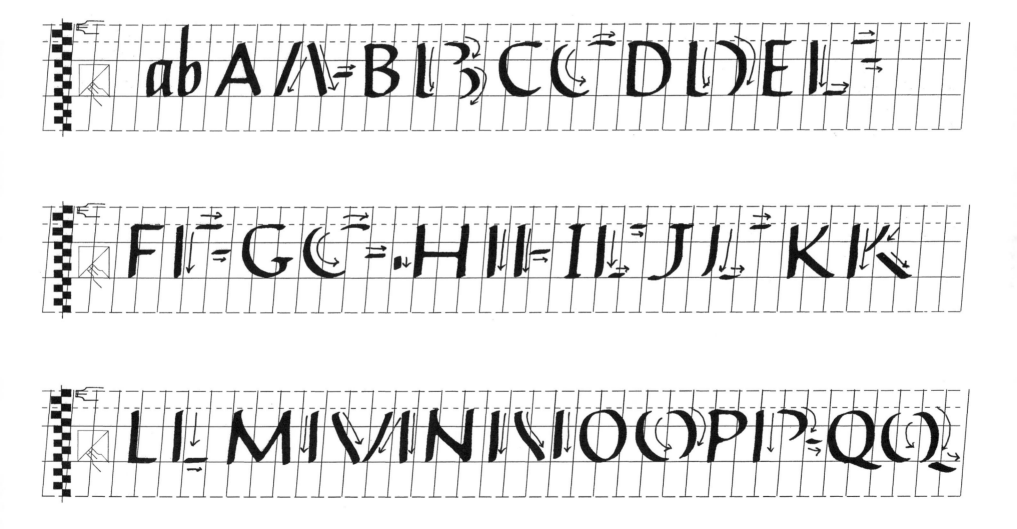

Uppercase (Majuscule) Italic Alphabet, Continued

Continue your practice with the uppercase Italic alphabet on the worksheet below. As before, the pen nib-width is 2mm. The other characteristics are as follows:

Pen Angle:	45° (except for diagonal strokes in letters *A, K, M, V, W, X, Y,* and *Z,* which require a flatter pen angle, of about 30°)
Pen Scale:	7½ nib widths for cap height
Letter Slope:	4°

Italic Uppercase (Majuscule) Alphabet Worksheet 2

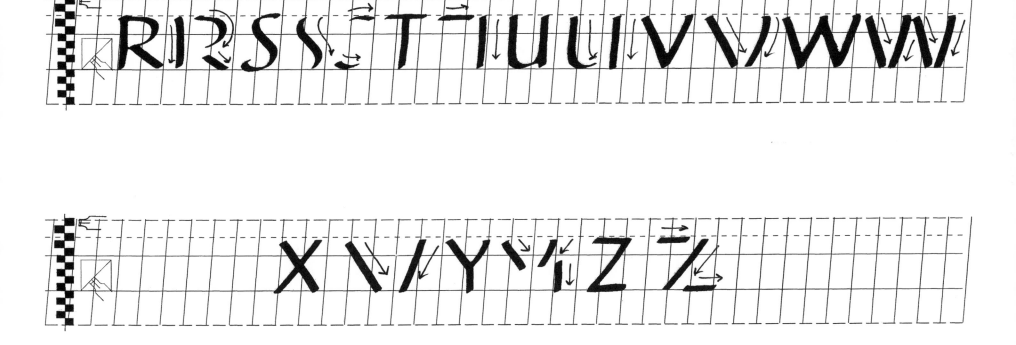

Italic Numerals and Punctuation

Because written Arabic numerals and punctuation marks evolved many years after the alphabets we study in this book, there are no historic examples from which to draw information. But by keeping the pen angle and proportion consistent, you'll end up with numerals and punctuation marks that look similar to the examples shown on the worksheet below.

There are older and newer styles of forming these numerals. In the newer style, which appears first on the worksheet, all the numerals fit within the standard Italic x-height of 5 nib widths. Some calligraphers, however, continue to use the *old style,* in which some numerals (the 5, the 9, and occasionally the 3) drop below the base line and the 6 sometimes encroaches into ascender territory. At the end of the worksheet, I've included an example of a Roman numeral. Note that when creating Roman numerals, you should make each character separately; do not make the top or bottom crossbar as a single stroke.

As with the other worksheets, the one below is designed for use with a pen nib measuring 2mm across. Except for the old-style numerals and the punctuation marks (whose size and placement vary from mark to mark), the characteristics are the same as those for Italic minuscules:

Pen Angle:	45°
Pen Scale:	5 nib widths for x-height
Letter Slope:	4°

Italic Numerals and Punctuation Worksheet

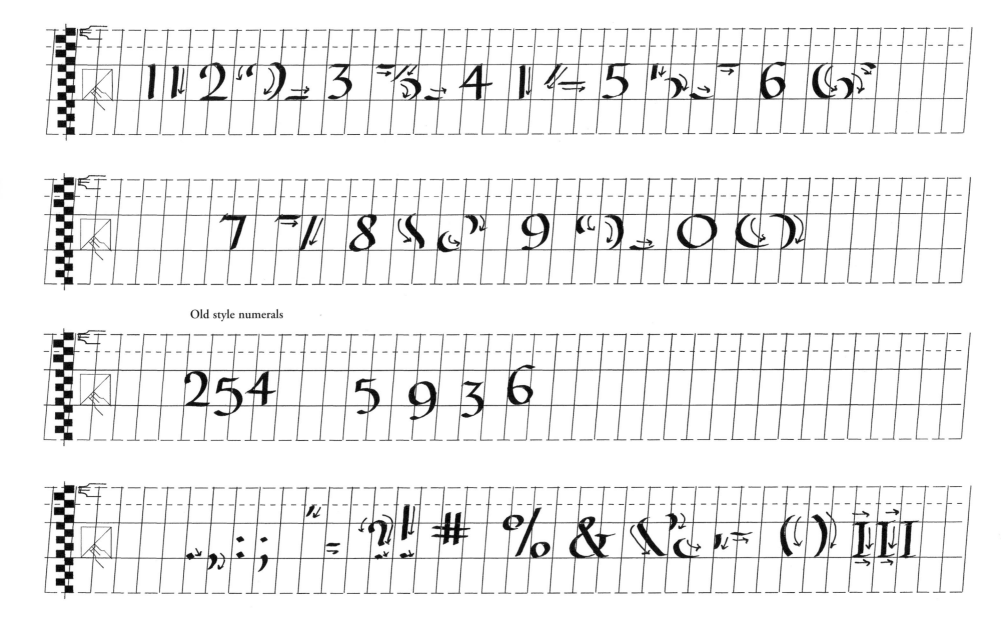

Old style numerals

Italic Serifs and Flourishes

A serif is a small shape, created by the pen, that appears at the beginning and/or the end of a stroke. Serifs primarily serve a decorative function. (A letter or alphabet that does not have serifs as part of its design is known as *sans serif,* meaning "without serifs.")

When a serif style is used, it must be used consistently throughout an entire alphabet: in other words, if you change your pen angle when making a serif, you must maintain the new pen angle for all the serifs in that alphabet. Serifs can be "constructed" in several different ways, as the samples at right show.

Flourishes also serve a decorative purpose, but they are more elaborate than serifs and are *not* used consistently throughout an alphabet. Often, a flourish is used at the beginning or end of a line of text to add emphasis.

There are many different types of serifs and flourishes, a few of which are illustrated on the worksheet below. When a flourish or serif is added, the basic letter shape remains unchanged, though in some cases the height of the finished letter will be increased, as happens to the uppercase *H* on the worksheet.

The extremely thin lines that are used in serifs and flourishes are commonly referred to as *hairlines.* They are accomplished by going up on the "corner" of your pen nib. This is done while the ink is still wet and slightly puddled at the end of your serif stroke.

At the lower right of the worksheet, you will notice a sample of what is called a *ligature.* A ligature is two letters joined together—in this case, by an elaborate serif.

Stroke Serif

Tick Serif

Bracketed Serif

These samples (just three among many possible serif styles for lowercase letters) show how serifs, when used, are carried through the entirety of an alphabet. Each serif style is "constructed" somewhat differently. Stroke and tick serifs both require the addition of a single, short stroke to the main stroke; bracketed serifs require the addition of two short strokes to the main stroke, as shown.

Italic Serifs and Flourishes Worksheet

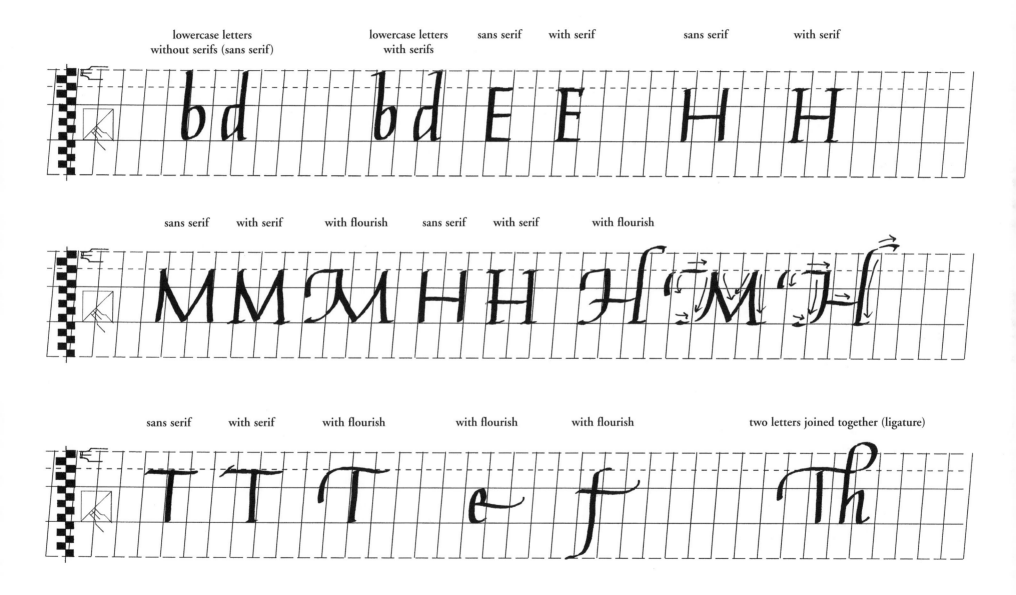

lowercase letters without serifs (sans serif) lowercase letters with serifs sans serif with serif sans serif with serif

sans serif with serif with flourish sans serif with serif with flourish

sans serif with serif with flourish with flourish with flourish two letters joined together (ligature)

o everything, there is a

eason, and a time to eve

urpose under the heaven

ime to be born, and a ti

o die; a time to plant; a

time to pluck up that t

as been planted. a time

ll and a time to heal;

The Uncial and Half Uncial Hands

THE UNCIAL (PRONOUNCED UN-SHULL) ALPHABET evolved from the fourth through sixth centuries and was the most commonly used bookhand of that time. (A *bookhand* is a lettering style used for the main text of a manuscript—as opposed to, say, a style used for versal capitals and other decorative elements.)

At this early period of calligraphy's development, there was no differentiation between minuscule (lowercase) and majuscule (uppercase) letters, so the Uncial hand contains only one alphabet. (In fact, some of the letters used today—for example, the letter *j*—didn't even exist at the time this alphabet first developed.)

During the sixth century, a minuscule alphabet began to emerge, and this style became known as *Half Uncial*. Half Uncial is a mixture, by today's standards, of majuscule and minuscule letters. Strokes on some of the letters, such as the *p* and *q,* drop slightly below the writing line—the first examples of what we now call descenders.

The Uncial and Half Uncial hands in this book provide you with a suitable alphabet for contemporary applications. Traditionally, the spacing between letters in these hands is quite close—so close that some letters may overlap—but there is wide spacing between lines; both traits can be seen in the lines from Ecclesiastes shown above.

Uncial and Half Uncial Skeletal Letter Shapes

Start your practice with the Uncial and Half Uncial alphabets with the Skeletal Letter Shapes worksheet below. Note that only 11 of the letters of the Half Uncial hand differ from those of the Uncial hand; these appear within separate guidelines at the bottom of the worksheet.

Use the same technique you used for the Italic Skeletal Letter Shapes worksheet: place a sheet of tracing vellum on top of the worksheet and secure it in position with drafting tape. With a pencil, carefully trace each of the skeletal shapes, paying close attention to the direction and sequence in which the strokes are made (indicated by the arrows and numbers). Again, make sure each skeletal shape fills the x-height completely and that the ascenders and descenders reach the indicated guidelines. And don't forget to pay attention to the counters (negative spaces) inside the letters as well as to the letters themselves.

Work through this exercise several times before proceeding to the next worksheet. Remember to exert only moderate pressure so as not to tear the vellum.

Follow the directional arrows and number sequence when creating skeletal letter shapes.

Uncial and Half Uncial Skeletal Letter Shapes Worksheet

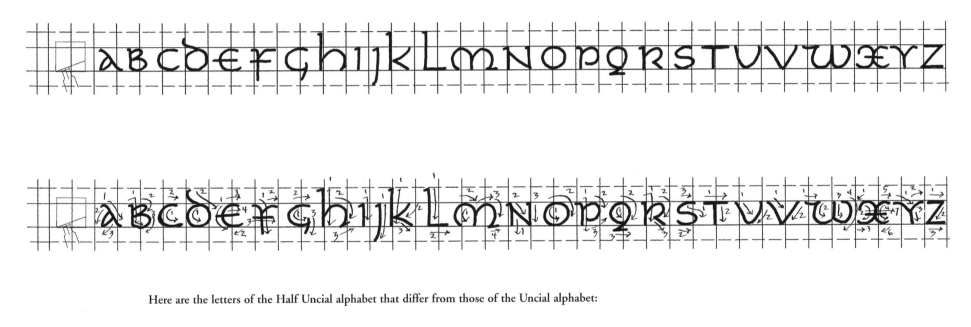

Here are the letters of the Half Uncial alphabet that differ from those of the Uncial alphabet:

Uncial and Half Uncial Basic Strokes

After you've practiced with the Skeletal Letter Shapes worksheet several times, move on to the Basic Strokes worksheet, below. To use this worksheet, switch to a broad-edged pen with a nib measuring 2mm across. Once again, tape a sheet of tracing vellum on top of the worksheet, and begin tracing the basic strokes, paying close attention to the direction in which each stroke is made. Note that only a few of the strokes for the Half Uncial alphabet differ from those for the Uncial alphabet.

The characteristics of the Uncial and Half Uncial hands are as follows:

Pen Angle:	20°
Pen Scale:	3 nib widths for x-height
	2 nib widths for ascenders (Only three letters—*h, k,* and *l*—have full-length ascenders; these ascenders should measure about 2 nib widths. The letter *d* has a slight ascender, which measures about 1½ nib widths.)
	2 nib widths for descenders
Letter Slope:	0°

Uncial and Half Uncial Basic Strokes Worksheet

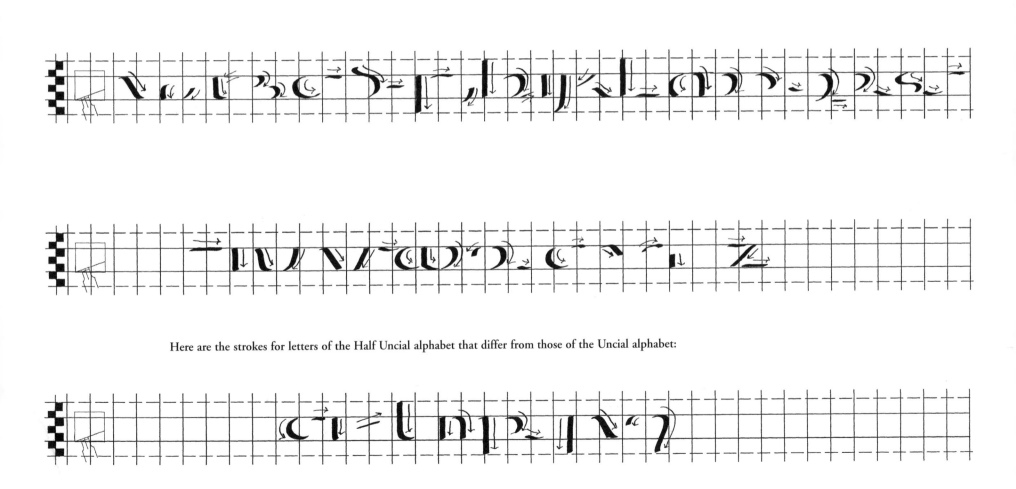

Here are the strokes for letters of the Half Uncial alphabet that differ from those of the Uncial alphabet:

Uncial Alphabet

As with all the alphabet worksheets in this book, you should take some time to carefully study the Uncial Alphabet worksheet, below, before attempting to write the letters yourself.

Working with tracing vellum secured to the worksheet, trace over the letters to familiarize yourself with the shapes. After working through the alphabet, you will be ready to switch to the Uncial and Half Uncial Guide Sheet at the back of the book. As you did with the Italic Guide Sheet, remove the perforated guide sheet from the book and, having made sure that it is perfectly horizontal, secure it to the surface of your drafting table or board with drafting tape. Place a sheet of tracing vellum on top of the guide sheet and secure it with drafting tape, as well. Keep this book close at hand and open to this worksheet page, referring to it constantly as you make each of the Uncial alphabet's letters.

This exercise also requires a pen nib measuring 2mm across. Remember that the Uncial letters have the following characteristics:

Again, the worksheet shows each completed letter first, followed by a "blown apart" letter showing stroke direction and sequence.

Pen Angle:	20°
Pen Scale:	3 nib widths
	2 nib widths for ascenders on *h, k,* and *l*
	1½ nib widths for ascender on *d*
	2 nib widths for descenders
Letter Slope:	0°

Uncial Alphabet Worksheet

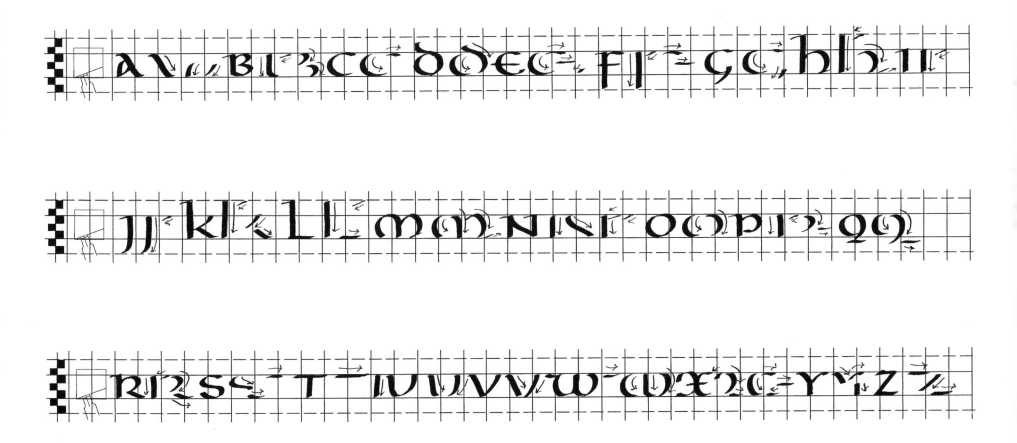

Half Uncial Alphabet

For this exercise, again work on the Uncial and Half Uncial Guidesheet, taping it to your drafting table and securing a sheet of tracing vellum on top of it before beginning. As you study the worksheet below, note once again that only 11 of the Half Uncial hand's letters—*a, b, e, l, m, n, p, q, t, u,* and *y*—differ from those of the Uncial hand. The Half Uncial *a* and *e* are similar to the lowercase forms of these letters today, but most of the letters remain closer to their majuscule origins.

As usual, use a pen with a nib measuring 2mm across for this exercise. Here again are the characteristics of the Half Uncial hand:

Pen Angle:	20°
Pen Scale:	3 nib widths for x-height
	2 nib widths for ascenders
	2 nib widths for descenders
Letter Slope:	0°

Half Uncial Alphabet Worksheet

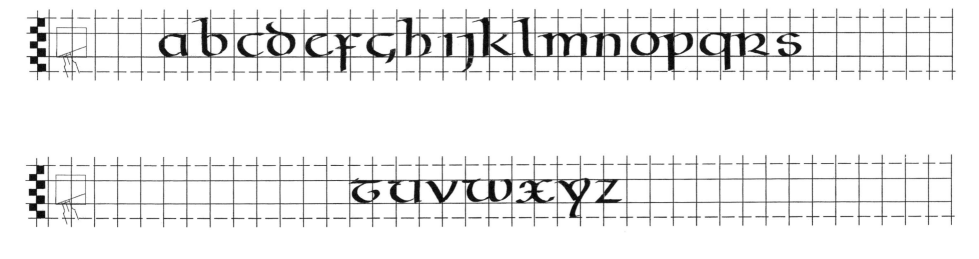

abcdefghijklmnopqrs

tuvwxyz

Here are the letters that differ from those of the Uncial alphabet. Completed letters are followed by "blown apart" letters.

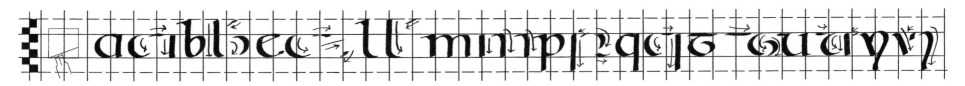

Uncial and Half Uncial Numerals, Punctuation, and Serifs

Because the Arabic numerals and punctuation marks we use today evolved long after the development of the Uncial and Half Uncial hands, modern calligraphers have had to create these characters to conform to the hands' characteristics.

The letters on the second set of guidelines, below, have been enlarged so that you can see the strokes and letter shapes more clearly. If you have purchased a 4mm pen nib, you might find it helpful to try to copy these letters in the larger size.

At the bottom of this worksheet, I show how the serifs for the Uncial and Half Uncial alphabets are "built-up" in a fashion similar to that of the bracketed serif shown in the Italic hand chapter (see page 52). But, as the worksheet shows, the Uncial serifs are a little more angular than those used in Italic lettering.

Uncial and Half Uncial Numerals, Punctuation, and Serifs Worksheet

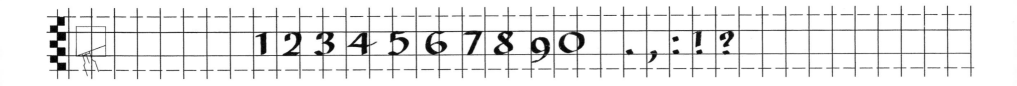

The enlarged examples below have been made with a 4mm pen nib so that strokes and letter shapes can be seen more clearly.

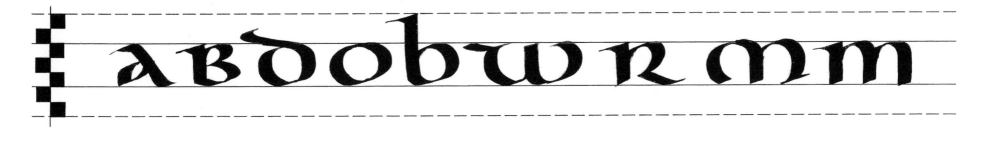

The "built up" serif traditionally used with Uncial consists of three strokes.

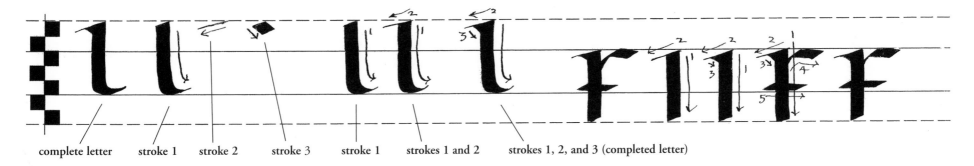

complete letter stroke 1 stroke 2 stroke 3 stroke 1 strokes 1 and 2 strokes 1, 2, and 3 (completed letter)

ipse me misit; Quare
autem scio eum. quia ab
sum & c; magnifice utru
q; monstrauit. ab ipso
inquid quia filius de pa
tre. et quic quid e filius
de illo e cuius e filius. ideo
dnm ihm dicimus. dm de
do. patrem nondicimus

hendere
in illum m
dum uen
Hoc e q
enim uo
uolunta
hoza pre
utatis si
predisan

The Carolingian Hand

IT MAY BE HARD TO BELIEVE that there's a direct connection between Charlemagne, whose reign as Holy Roman emperor began in 768, and today's calligraphers, but the Carolingian hand is precisely that. Following his conversion to Christianity, Charlemagne felt compelled to convert all of northern and western Europe to his newfound religion, and his dedication to—quite literally—spreading the word created the need for faster book production. The new, speedier script that developed as a result of his influence became known as Carolingian, after the Latin form of Charlemagne's name—Carolus Magnus.

The Carolingian alphabet, which developed in France during the ninth century, was the first minuscule (lowercase) alphabet to evolve. (Historians sometimes refer to it as Caroline Minuscule.) Because of the speed with which Carolingian letters were written, they acquired a slight slope (about 3 degrees), and there were small connections between some letters—a forerunner of the joined letters of cursive writing.

Historically, there was no Carolingian majuscule (uppercase) alphabet, because scribes used large decorated letters to denote the beginning of a new verse. Today's calligrapher can successfully use decorated capitals, Uncial letters, or Roman capitals with the Carolingian hand.

In this detail (above) from a 10th century manuscript, you can clearly see the small connections linking some of the letters, as well as the generous line spacing typical of Carolingian manuscripts. When writing out text in the Carolingian hand, the line spacing should be at least twice the x-height to maintain this traditional ratio between lettering and white space on the page.

MS no. 95, folio 37r, Boston Public Library, Rare Book Department. Courtesy of the Trustees of the Boston Public Library.

Carolingian Skeletal Letter Shapes

Begin practicing the Carolingian hand with the Skeletal Letter Shapes worksheet, below. Use the same technique you used for the other skeletal letter shapes worksheets: tape a sheet of tracing vellum on top of the worksheet, and carefully trace each of the skeletal shapes in pencil, exerting only moderate pressure. As before, make sure each skeletal shape fills the x-height completely and that the ascenders and descenders reach the indicated guidelines. Pay attention to the counters (negative spaces) inside the letters as well as to the letters themselves.

Do all the letters several times before going on to the next exercise.

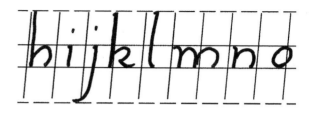

Be sure to fill the space for the ascenders and descenders completely.

Carolingian Skeletal Letter Shapes Worksheet

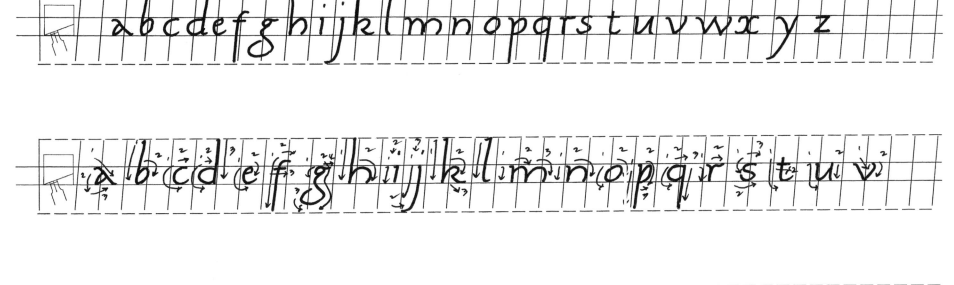

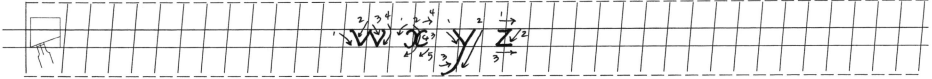

Carolingian Basic Strokes

Using tracing vellum and a 2mm broad-edged pen, trace over the basic strokes of the Carolingian alphabet on the worksheet below.

The Carolingian hand, like other historical hands, developed before Arabic numerals came into use. By keeping the pen angle, letter proportion, and letter slope consistent, however, we can produce numbers that are visually compatible with the Carolingian alphabet, as the worksheet shows.

The characteristics of the Carolingian hand are as follows:

Pen Angle:	20°
Pen Scale:	2½ nib widths for x-height
	4 nib widths for ascenders
	4 nib widths descenders, except for the descender on *g*, which is about 3 nib widths
Letter Slope:	3°

Carolingian Basic Strokes Worksheet

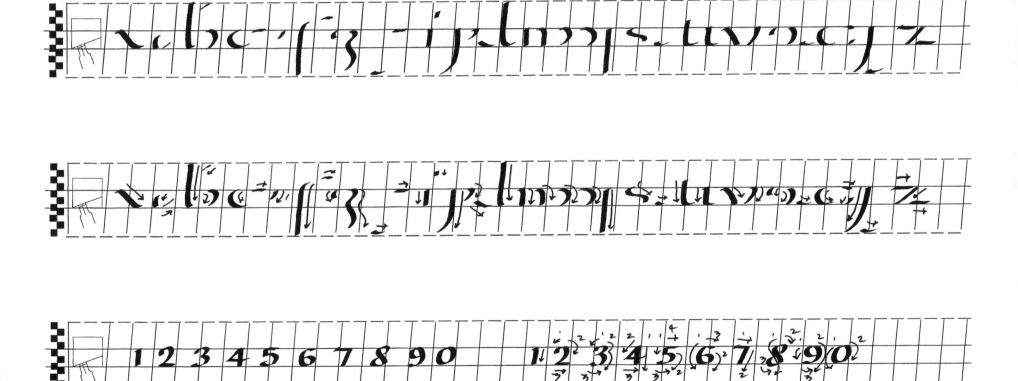

Carolingian Alphabet

After a little practice with the Basic Strokes sheet, you can go on to the Carolingian alphabet itself. Once again, use the tracing technique for this alphabet before going on to the guide sheet from the back of the book. When ready, remove the Carolingian Guide Sheet from the book and tape it to your drafting table. Tape a sheet of tracing vellum on top, and begin your lettering. Keep this book next to your work area to refer to as you write each of the letters.

Use a pen with a nib measuring 2mm. Notice again that there are 10 nib widths of space between lines written in the Carolingian alphabet. Here, once more, are the alphabet's characteristics:

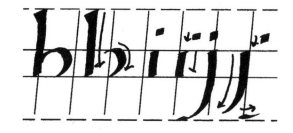

As on previous worksheets, the full letter is shown first, then the "blown apart" letter showing stroke direction and sequence.

Pen Angle:	20°
Pen Scale:	2½ nib widths for x-height
	4 nib widths for ascenders
	4 nib widths descenders, except for the descender on *g*, which is about 3 nib widths
Letter Slope:	3°

Carolingian Alphabet Worksheet

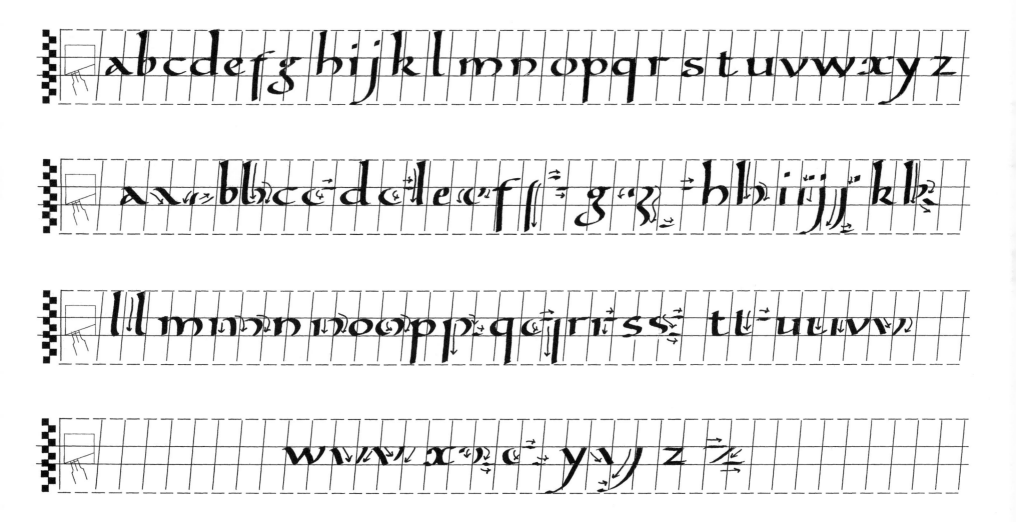

Better is
a dinner of
herbs
where love is

The Gothic, or Black Letter, Hand

THOUGH COMMONLY KNOWN as the Gothic (or Old English) hand, this complex and angular lettering style is often referred to by calligraphers as the Black Letter hand. The hand, which evolved during the 14th century, merits that name because of the appearance of a page of text lettered in this style. The hand is so tightly spaced and contains so many regular, vertical, thick, dark lines that it seems to cover the page in black.

The minuscules of the Gothic hand—which I'll refer to from now on by this, its more familiar name—require a great deal of pen lifting, as each letter is composed almost entirely of vertical strokes, which are connected by small diagonal strokes. Because of the constant pen lifting this hand demands, it takes a long time to produce a document lettered in Gothic. The line spacing is quite tight because of the short ascenders and descenders. Oftentimes, the spacing between lines is equal to the x-height.

Gothic Skeletal Letter Shapes

As with the previous hands, start out by tracing the skeletal letter shapes with a pencil on tracing vellum taped onto the worksheet page, below. Work through this important exercise several times before going on.

On this and all the Gothic worksheets, you will notice that I have added four lightly dotted lines to each set of guidelines. These lines, which fall just inside the x-height and ascender and descender lines, represent the spots at which the angle of the stroke changes (or the pen is lifted). To get a clearer understanding of the purpose of the dotted lines and the placement of the strokes, refer to the enlarged letters worksheet on page 85.

The lightly dotted lines on the Gothic worksheets indicate places where the angle of the stroke changes.

Gothic Minuscule Skeletal Letter Shapes Worksheet

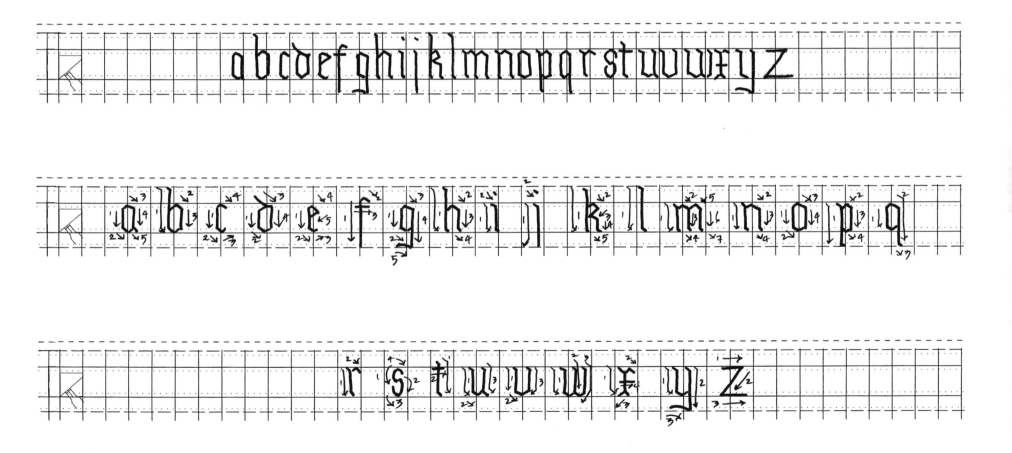

Gothic Minuscule Basic Strokes

Using a 2mm pen nib, trace the basic strokes on tracing vellum taped to the worksheet, below. Gothic has fewer basic strokes than the other hands, but it is an *extremely* regular lettering style, which means that it is critically important to maintain an absolutely consistent pen angle as you letter.

Because the positioning of the strokes is so critical for the regularity of this hand, I have added a set of enlarged basic strokes to this worksheet. These enlargements are intended as a visual aid to help you understand the strokes' placement. If among the pen nibs you have purchased there is one measuring 4mm across, it might be worthwhile for you to trace these enlarged letters. Additionally, you will notice a set of numerals at the bottom of this worksheet.

The characteristics of the Gothic hand's minuscule letters are as follows:

Pen Angle:	40°
Pen Scale:	4 nib widths for x-height
	2 nib widths for ascenders, except for the ascenders on *d, f,* and *t,* which are about 1 nib width
	2 nib widths descenders
Letter Slope:	0° (vertical)

Gothic Minuscule Basic Strokes and Numerals Worksheet

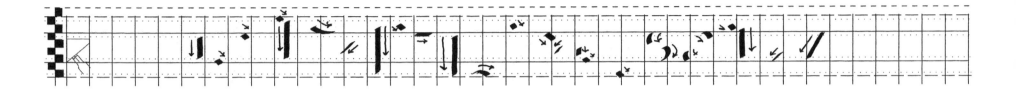

The strokes below have been enlarged to show how the strokes are shaped and where they are positioned.

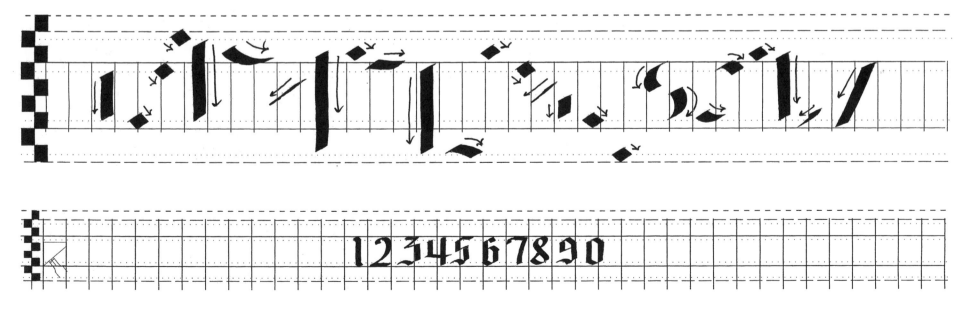

1234567890

Gothic Minuscules

Now that you've practiced your hand at making the basic strokes for Gothic minuscules, it's time to progress to the letters themselves. As with the preceding hands, trace over the Gothic minuscules using the tracing vellum and drafting tape technique before moving on to the sheets in the back of the book. After tracing, remove the Gothic Guide Sheet from the book and tape it to your drafting table. Tape a sheet of tracing vellum on top, and begin your lettering. Keep this book nearby to refer to as you write the letters.

Use a pen with a nib measuring 2mm across for this exercise. Here, to remind you, are the characteristics of Gothic minuscules:

The worksheet again shows the complete letter first, followed by the "blown apart" letter. Gothic letters can be rather more complicated than those of other hands, requiring upwards of eight separate strokes, as in the *w*.

Pen Angle:	40°
Pen Scale:	4 nib widths for x-height
	2 nib widths for ascenders, except for the ascenders on *d*, *f*, and *t*, which are about 1 nib width
	2 nib widths descenders
Letter Slope:	0° (vertical)

Gothic Minuscules Worksheet

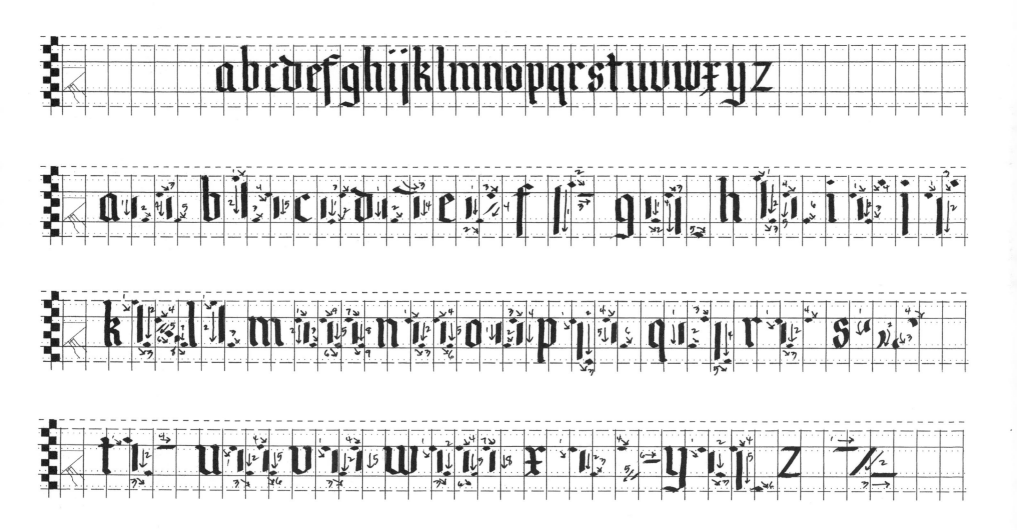

Gothic Majuscules

It only takes one glance at the letters on the worksheet below for you to realize that the capital letters of the Gothic alphabet are quite different from anything we've created previously. Like most of the hands we've already studied, Gothic was originally a *text* hand, so there aren't many historical examples of Gothic majuscules dating back to 14th and 15th centuries. The ornate capitals we associate with the Gothic hand were designed later, following the invention of the printing press. Because these capital letters were reproduced with type blocks (rather than being off-the-pen letters) they could be painstakingly designed in an ornate style.

The Gothic majuscules on the worksheet are designed to be created with one pen—the same 2mm nib-width pen we've been using all along. Although the letters have many curved strokes (and the interior areas of some letters contain decorative strokes), it should be relatively easy for you to determine how to make these letters based on the criteria we've studied: pen angle, pen scale, and letter slope. Once again, you should do this exercise on the Gothic Guide Sheet you've removed from the back of the book. The characteristics of Gothic majuscules are as follows:

Elaborate Gothic capitals demonstrate little consistency of pen angle and, in fact, are often made with two or more nibs—which is why the decorative strokes are often much narrower than the letter strokes, as in this example.

Pen Angle:	40°
Pen Scale:	7 nib widths for cap height
Letter Slope:	0° (vertical)

Gothic Majuscules Worksheet

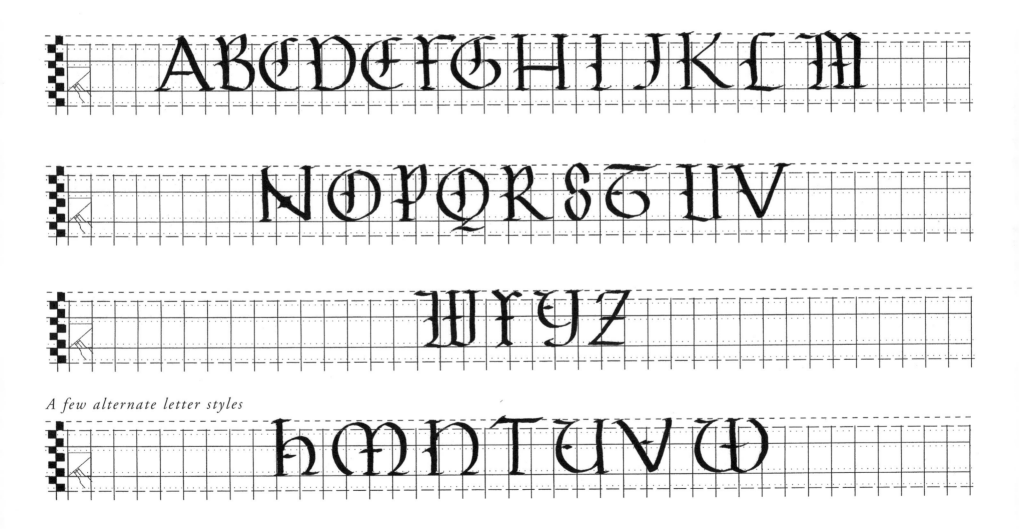

A few alternate letter styles

Enlarged Gothic Sample Letters

Because of the complexity of the Gothic alphabet, I've included this sheet of enlarged letter samples to assist you in your study. Please note the lightly dotted lines, which indicate where the direction of the stroke must be changed (or the pen lifted) when creating the minuscule letters.

Again, the characteristics are as follows:

Pen Angle:	40°
Pen Scale:	4 nib widths for x-height
	2 nib widths for ascenders
	2 nib widths descenders
	7 nib widths for cap height
Letter Slope:	0° (vertical)

Enlarged Gothic Sample Letters

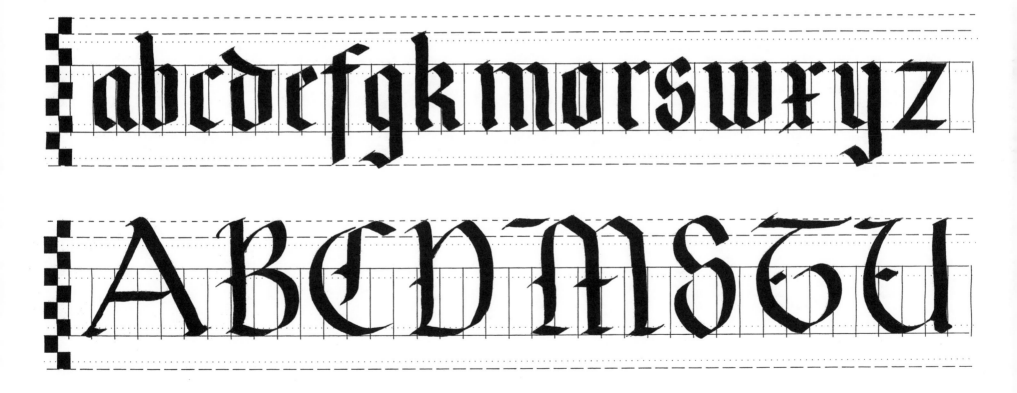

abcdefgkmorswxyz

ABCDMSTU

The best portion of
a good man's life -
his little nameless
unremembered acts
of kindness and of

LOVE

The Foundational Hand

AFTER THE INVENTION OF THE PRINTING PRESS in the 15th century, book production changed dramatically—and with it, letter production. The transition was under way to move from pen-made letters to letters printed from carved blocks of wood, which, when inked, allowed multiple copies of the same text to be produced almost simultaneously. This new technology had the wonderful benefit of making many more books available to a vast number of people, but it dealt a death-blow to the craft of creating letters with the broad-edged pen.

At the turn of the 20th century, after nearly 400 years of diminishing use, broad-edged pen lettering began to reemerge as an art form, due mainly to the efforts of Edward Johnston (1872–1944). Johnston, whose influential book *Writing & Illuminating & Lettering* was published in 1906 and is still available today, is credited with single-handedly bringing calligraphy back from the dead. Among his many lasting contributions was the creation of a pen-made alphabet fashioned after the stone-cut Roman alphabet. Because the Roman alphabet is considered the foundation of our western alphabet, Johnston's pen-made alphabet became known as the Foundational hand (although it is occasionally referred to as Roundhand or Bookhand).

Foundational Minuscules Skeletal Letter Shapes

Using the same tracing vellum-and-pencil technique described previously in this book, trace the skeletal shapes of the Foundational minuscules to get a feel for how each letter is formed. As always, study the counters (negative spaces) as well as the letters themselves, and do the exercise several times before progressing to the basic strokes worksheet.

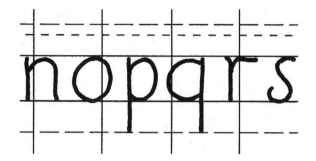

It is important to keep your letters perfectly vertical when lettering in the Foundational style.

Foundational Minuscules Skeletal Letter Shapes Worksheet

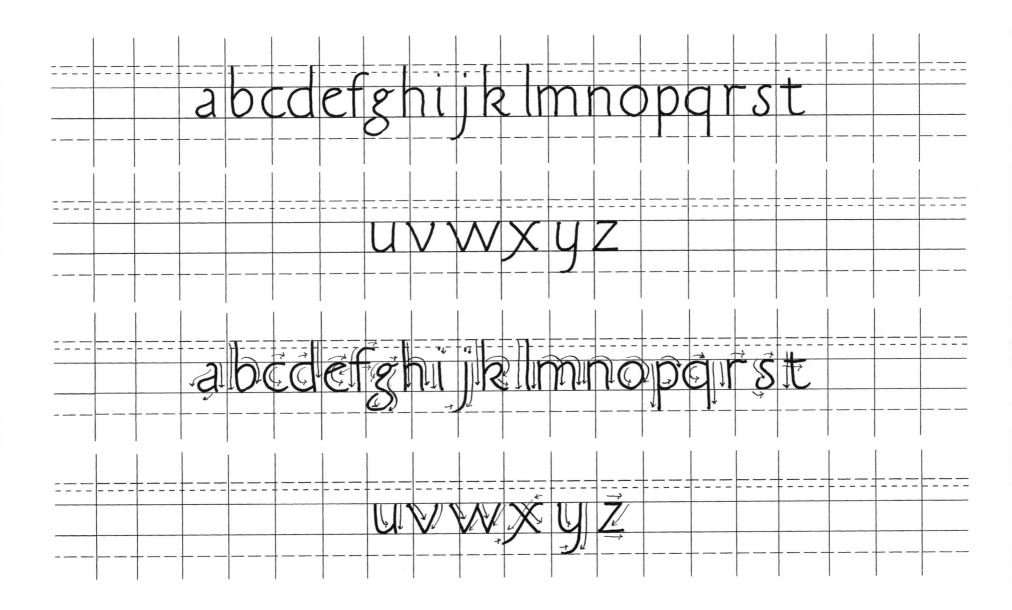

Foundational Basic Strokes

As you've done with the other basic strokes worksheets, place a sheet of tracing vellum over the Foundational Basic Strokes worksheet, below; secure the vellum with drafting tape; and trace the strokes using a 2mm pen nib. As with all calligraphic alphabets, be sure to keep the pen angle consistent.

As on several of the other worksheets, I have included information on numerals and punctuation marks here. I've also included a section of enlarged letters to help you learn how to make Foundational hand serifs, which are created in three steps. Though making these serifs may at first feel slow and cumbersome, you will find that your speed will increase with practice.

The characteristics of Foundational minuscules are as follows:

Pen Angle:	30°
Pen Scale:	4 nib widths for x-height
	3 nib widths for ascenders (except for the *t* and the *f,* which are 1 and 2 nib widths, respectively)
	3 nib widths for descenders
Letter Slope:	0° (vertical)

Foundational Basic Strokes, Numerals, Punctuation, and Serifs Worksheet

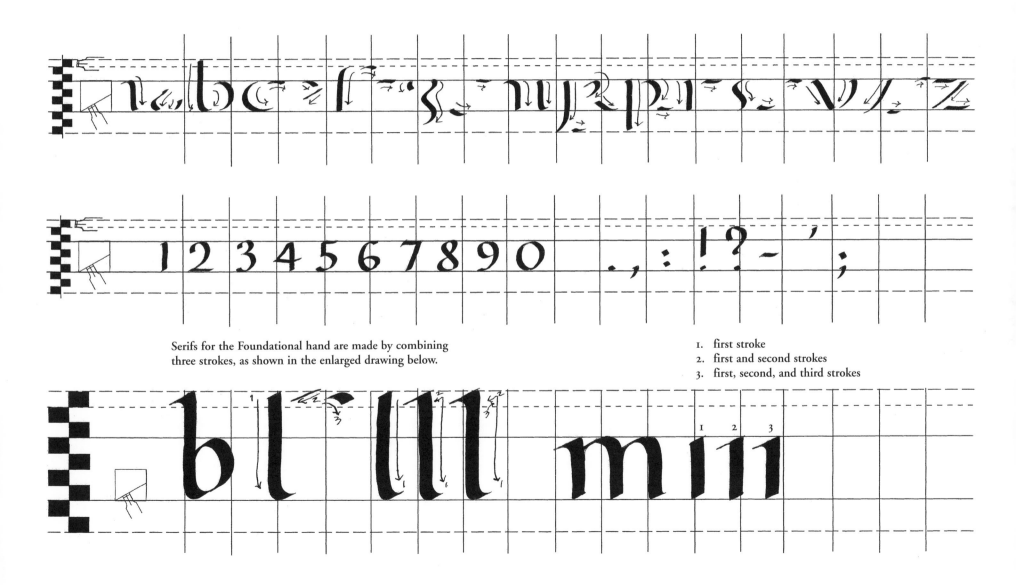

Serifs for the Foundational hand are made by combining three strokes, as shown in the enlarged drawing below.

1. first stroke
2. first and second strokes
3. first, second, and third strokes

Foundational Minuscules

Now that you've practiced the basic strokes for Foundational minuscules, move on to the letters themselves, as shown on the worksheet, below. As before, trace the alphabet before proceeding to the guide sheet. Afterwards, you should switch to the Foundational Guide Sheet. Remove it from the back of the book, position it and secure it on your drafting table, and tape a sheet of tracing vellum overtop before beginning. Refer to the worksheet as you make each of the letters.

This exercise requires a 2mm pen nib. Here, again, are the characteristics of the Foundational hand's minuscule alphabet:

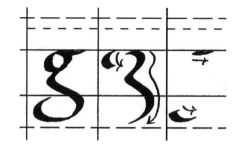

Again, the full letter is shown first, followed by the "blown apart" letter.

Pen Angle:	30°
Pen Scale:	4 nib widths for x-height
	3 nib widths for ascenders (except for the *t* and the *f*, which are 1 and 2 nib widths, respectively)
	3 nib widths for descenders
Letter Slope:	0° (vertical)

Foundational Minuscules Worksheet

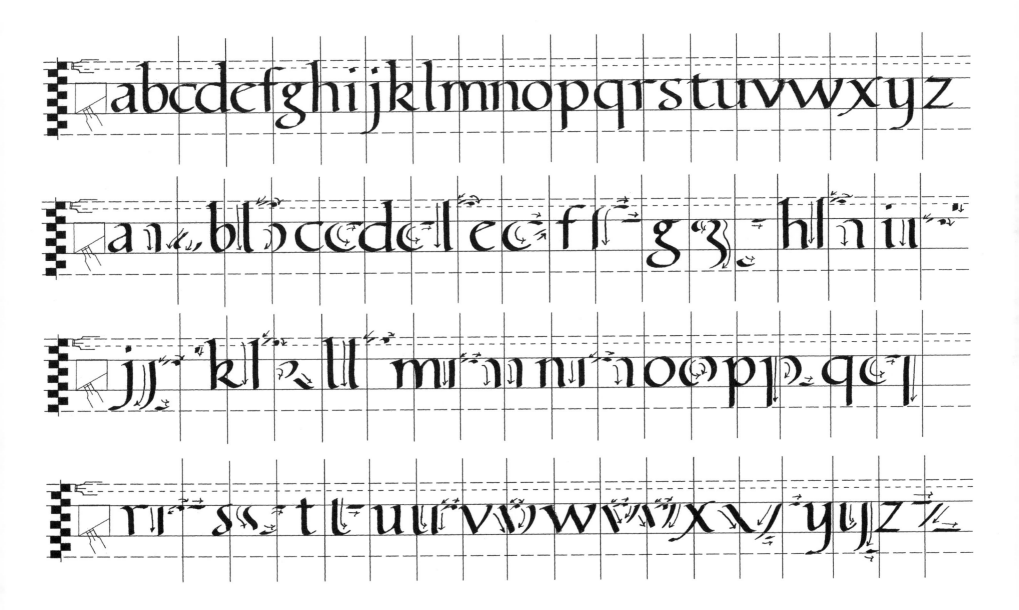

Foundational Majuscules

The majuscules of the Foundational hand are based on incised Roman letters, such as those that appear in the inscription at right. The letters of such ancient inscriptions were chiseled from stone, which allows the creation of a delicate serif. In the Foundational majuscule alphabet, we imitate these chisel-made serifs with the broad-edged pen.

Before using the guide sheet at the back of the book, trace over the alphabet, below, using tracing paper secured to the page with drafting tape. Then, secure the Foundational Guide Sheet to your drafting table, with a sheet of tracing vellum taped on top of the guide sheet, begin lettering. This exercise requires a 2mm pen nib. The characteristics of Foundational majuscules are as follows:

This Roman inscription appears on a tombstone, dating from about AD 150, in a cemetery near the capital of Roman Dacia, in present-day Romania.

Photography by Alexandru Florescu for iStockPhoto.com.

Pen Angle:	30°
Pen Scale:	6 nib widths for cap height
Letter Slope:	0° (vertical)

Foundational Majuscules Worksheet

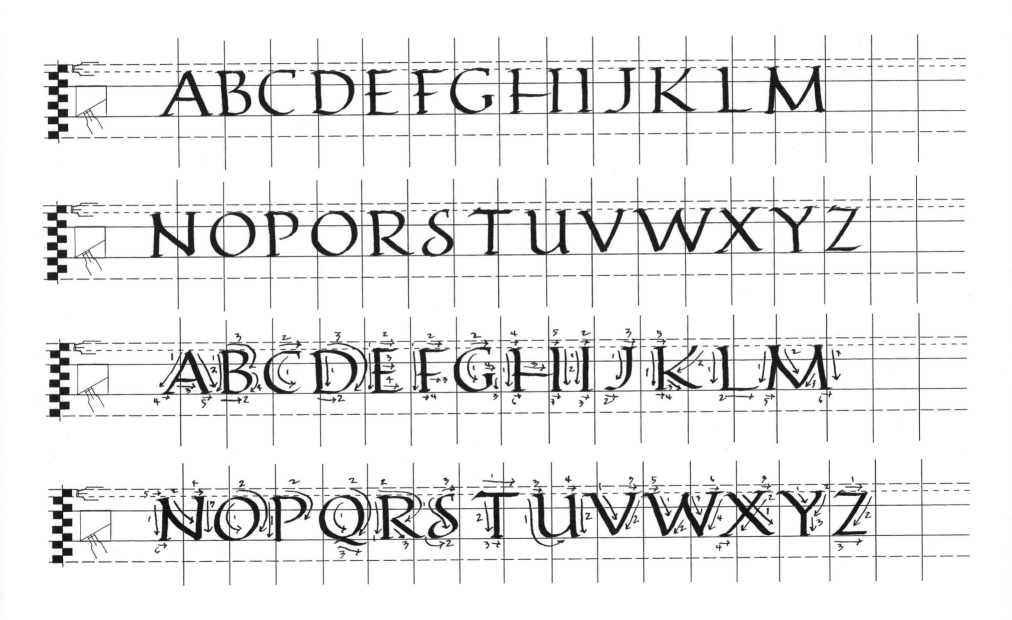

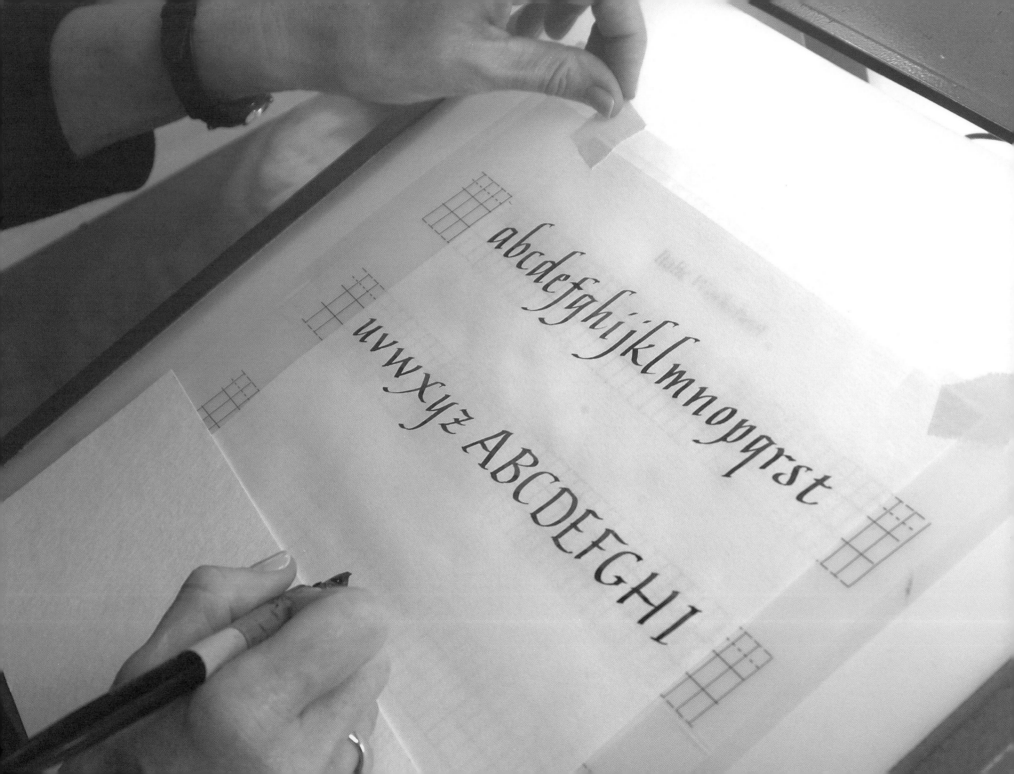

abcdefghijklmnopqrst
uvwxyz ABCDEFGHI

Design Tools

DESIGN IS A VERY BIG TOPIC, so we can only touch on a few of the basics in this book. In this chapter, we begin our exploration of layout and design by looking at four important tools that calligraphers use when creating finished pieces: the T square, the light box, the centering ruler, and the electric eraser. In the following chapter, we'll move on to some basic techniques that you can use when developing designs—and we'll get you started on creating your own projects.

Using a T Square

The first step when transitioning from writing out alphabets to creating a finished piece is to make pencil guidelines directly on a sheet of art paper. At first, you might want to transfer all the guidelines—x-height, capital-letter height, ascender and descender heights, as well as the letter slope. Eventually, you will need only to transfer the x-height lines; the rest will begin to come naturally to you.

The best tools for drawing your pencil guidelines are a T square and a mechanical pencil with very hard (HB) lead in 0.5mm thickness, which will make very light lines that can be easily erased.

For practice, let's walk through this procedure by transferring the x-height from the Italic Guide Sheet at the back of this book to your piece of art paper.

First, we will make a "paper ruler." Take a scrap of paper with even edges (a 3" × 5" index card will work well), and position it so that the paper's long edge runs alongside one set of x-height lines on the Italic Guide Sheet. Make three very small "tick" marks on the edge of the paper: two for the x-height and the third for the distance you want between your writing lines (for this exercise, let's use 10 nib widths—approximately three-quarters of an inch—as the space between writing lines). Your paper ruler should look something like the one in the drawings at right.

Next, we will transfer the information on your paper ruler to your art paper. Let's assume you will need five writing lines for your finished piece. As you go through this exercise, be mindful of how much total space the five writing lines will require. Try to work more or less in the center of the art paper, leaving space for a margin between your lettered text and the art paper's edge.

Working with an 8 1/2" x 11" (or similiar) piece of paper, placed vertically, begin making your pencil marks about one-quarter of the way down the page (from the top). Center the marks between the left and right-hand edges of the paper. Start by making three small pencil dots indicating the x-height for the first line of text and the space between writing lines (use a very tiny dot and a very light touch, or you will scar the art paper).

The bottom pencil dot on the art paper will become the top of the x-height space for the second writing line. Slide the paper ruler down so that the top x-height line on the paper ruler is aligned with the bottom dot on the art paper. Now make two more dots on your paper: the first will complete the x-height for the second writing line, and the second will mark off the space between the second and third writing lines. Continue this procedure until you have pencil dots for five writing lines on the art paper (ten dots, altogether).

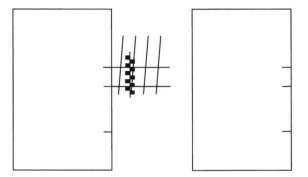

As shown in the drawing on the left, transfer measurements from the Italic Guide Sheet to your paper ruler, marking the scrap paper's long edge with indicators for the x-height (five nib widths) and for the spacing between lines (in this case, twice the x-height, or 10 nib widths). The drawing on the right shows the finished ruler. After making a paper ruler, you can label it (in this case, "X-Height for Italic Alphabet, 2mm Pen") and keep it in your files for future use.

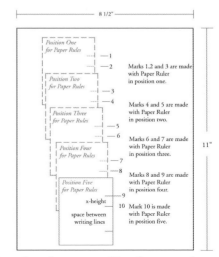

The above shows how to reposition the paper ruler as you work your way down the sheet of art paper, marking dots (represented by lines in the drawing) where you will draw your writing lines with the T square.

The T square allows you to create perfectly straight horizontal lines on the art paper. Assuming you are right-handed, position the T square so that the long ruling edge of the T square runs horizontally across your drafting table and the "T" is pressed against the table's left-hand edge. Holding the "T" against the table's edge allows you to slide the T square up and down while maintaining a perfectly horizontal rule. Position the top edge of the art paper along the horizontal edge of the T square. Using two small pieces of drafting tape, secure the art paper in that position. Now, slide the T square up and down across the surface of the art paper, lining the rule up with each dot and drawing a pencil line through it and across the whole width of the paper, as shown in the photo at top right. (These lines will eventually be erased, so make them as light as possible.)

Now, using an extra-soft no. 1 pencil to create skeletal letter shapes, write out the text of your choice, filling the five writing lines. It's helpful to pencil in other guidelines, as well—including lines indicating the left and right margins—to ensure that your lettering exactly fills the desired space. To draw vertical lines, you can either untape the art paper and reposition it sideways, drawing the lines with the T square, or you can place a right-angled triangle along the edge of the T square, drawing the vertical lines along the edge of the triangle that's perpendicular to the T square. Once everything is penciled-in and proofread, use your broad-edged pen to letter the text.

A note on using a triangle rather than a T square: Although I strongly urge you to purchase a T square if you have any serious interest in calligraphy, I recognize that T squares are expensive and that they are not easy to store or transport. A reasonable alternative is a plastic triangle with a 90-degree angle—that is, a right angle. When using a triangle rather than a T square, go through the same procedure of making a paper ruler and then marking the art paper with small, penciled dots indicating where you want your horizontal guidelines to be. Then line up the vertical edge of the art paper with one edge of the triangle's right angle, as shown in the photo at bottom right. The other edge of the right angle will form a horizontal line across the paper, and by sliding the triangle up and down, you can draw the guidelines. To ensure that your guidelines are precisely parallel, you must continually check to make certain that the edge of the triangle and that of the paper are properly aligned.

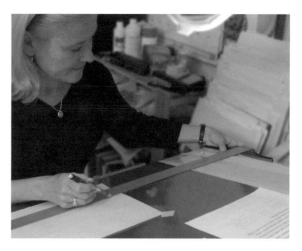

Using the T square, draw ten horizontal lines (one through each of the pencil marks you've made on the art paper), which will give you five writing lines (x-heights) on the art paper.

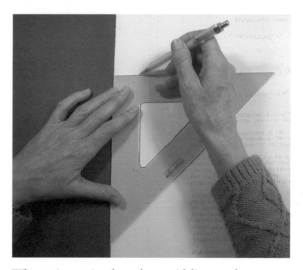

When using a triangle to draw guidelines, make sure to keep the triangle's vertical edge perfectly aligned with that of the art paper.

Using a Light Box

A light box is just what its name implies: a metal box with a clear or frosted Plexiglas top and a light bulb inside. Often used to view and sort slides, light boxes are also valuable tools for calligraphers and graphic designers.

In some calligraphy projects, it's not a good idea to draw guidelines directly on the paper you'll be lettering. This is one case where the light box comes in handy, since it enables you to see guidelines drawn on another surface beneath the paper you're working on. For example, if you're lettering invitation envelopes, you can make a guideline sheet with tracing vellum cut to a size just small enough to fit inside the envelope. On the tracing vellum, ink in the x-height guidelines that you have determined based on pen scale and envelope size. Slide this vellum guidelines sheet inside the envelope, place the envelope on the light box, and voila! You can clearly see the guidelines and follow them while lettering, eliminating the need to draw and erase pencil lines.

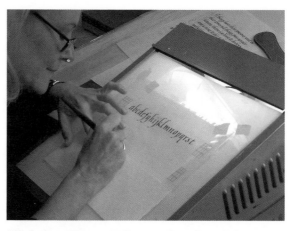

A light box allows guidelines to show through from beneath the art paper.

Using a Centering Ruler

Inaccurately centered text can spoil the effect of an otherwise beautifully lettered piece. Luckily, centering text is not difficult if you use a centering ruler—a ruler on which the zero appears in the center and distance from the center is marked off, in inches, to both the left and the right. Here's my favorite technique for precisely centering any number of lines of text on a page. To follow this method, you will also need a light box.

Accurate centering is most easily accomplished with a centering ruler.

1. Draw pencil guidelines for the text lines on your art paper. Also draw a vertical pencil line indicating the precise center of the area to be occupied by text.

2. Working directly on the art paper, write out the text in pencil, using skeletal letter shapes and positioning line breaks where you want them to appear in the final piece.

3. Position a piece of tracing vellum over your art paper and secure it in place with drafting tape. With pen and ink, write out the text on the vellum, following the guidelines you have drawn on the art paper (which will be visible through the vellum). Make sure to break the lines in the same places you indicated in step 2.

4. Once the ink on the tracing vellum has dried, use a centering ruler to individually mark the exact center of each line of text.

5. Tape the vellum to the Plexiglas surface of a light box. Turn on the light!

6. Keeping in mind that you will be repositioning the art paper before lettering each new line of text, place the art paper on top of the vellum, precisely aligning the inked first line of text on the vellum with the pencil guidelines for the first line of text on the art paper. Important: Be sure you also align the center line on the art paper with the center mark in the first text line. Secure the art paper with drafting tape and letter the first line of text.

7. Now reposition the art paper so that the second line of inked text on the vellum is aligned with the pencil guideline for the second line of text on the art paper. Be sure that its center mark corresponds to the center line, as described in step 6. After lettering this line of text, continue in the same fashion until all the text is lettered.

Using an Electric Eraser

As any calligrapher will sadly tell you, making an error in ink on a piece of art paper usually means that you must start all over again. (This is a good place to stress the importance of penciling-in *all* your work before inking anything—and to proofread, proofread, *proofread* before inking!)

Luckily, however, it is possible to erase *some* relatively small mistakes with the aid of a special device: an electric eraser. An electric eraser is a drafting tool that rotates an eraser at a high speed, allowing you—if you're very careful—to remove a small amount of ink from paper. (There are several models of electric eraser on the market; one is shown at right.)

Electric erasers only work if you are using high-quality art paper, and you may need to experiment with several different erasers before you have any measure of success. A word to the wise: Try this only if the correction is small—involving no more than one or two letters. It is nearly impossible to erase larger errors, and you will only frustrate yourself and waste time by trying. If the mistake involves an entire word or more, walk away from your work and start over at a later date.

If it's a small mistake you're trying to erase, here's the procedure:

1. Let the lettering dry completely. If the ink and paper are not totally dry, you risk smearing the ink or tearing the paper as you try to make the correction.

2. Place a sheet of protective paper (your hand blotter will work well) under the paper where you want to make the correction.

3. Using either a razor blade or an X-Acto knife, gently scrape the surface of the ink you want to remove. (This will get rid of some of the ink.)

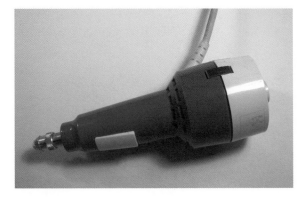

Although electric erasers can remove some small mistakes, they must be used very carefully.

4. Turn the electric eraser on, and gently dab the rotating eraser on the inked area you are trying to remove. Don't press the eraser down on the paper, as this may result in your making a hole in the paper. Continue gently touching the eraser to the paper until all the ink is removed. Be sure to remove every bit of ink—don't leave any shadow or bits of ink behind.

5. In pencil, redraw the guidelines and the skeletal shapes of the letters needing correction.

6. Dust Sandarac on the erased surface to provide a little "resist." Sometimes the area of the paper that has been erased will be especially porous and the ink will bleed as you try to re-letter. Sandarac helps prevent this.

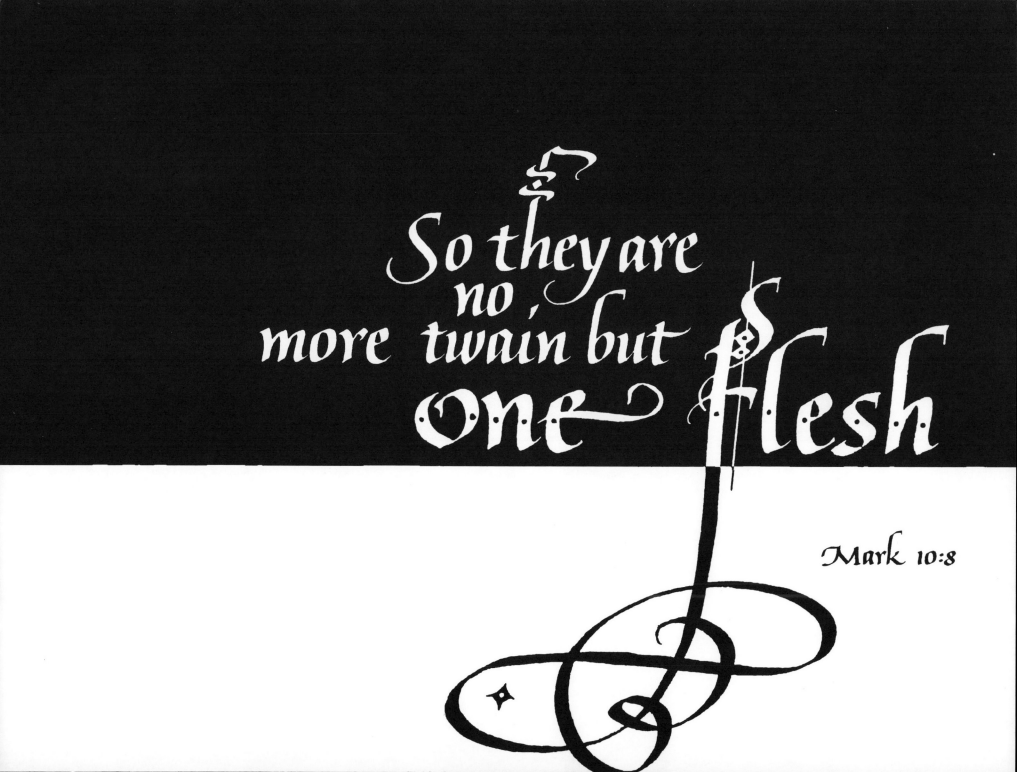

Layout Basics

YOU CAN ENJOY MAKING ALPHABETS for only so long. Soon after becoming familiar with an alphabet you will want to use it to letter quotations, poems, invitations, envelopes, correspondence, certificates—anything! But to make these pieces attractive, you need to consider the overall design of a piece as well as the lettering style.

Layout and design allow you to make a visual statement and spark the viewer's interest in what you have written. Visual interest can be added to a hand-lettered piece in many ways: through the use of color, the positioning of the text on the paper, the use of multiple lettering styles and sizes, the choice of format (horizontal versus vertical), the selection of the paper, and the inclusion of one or more decorative elements. The possibilities are so vast that taking the first step toward eliminating some options is often the most difficult part of the task. Start simple. The clean directness of a simple but well-executed design will win out against a piece that is "full of stuff" but poorly designed.

Contrast can also add interest, but here again, simplicity is best. A piece that has two or three contrasting elements—for example, traditional lettering combined with contemporary decorative elements—can be playful and effective, but a piece with too many contrasting elements can confuse the viewer. Always remember that the purpose of calligraphy is to convey the written word in a beautiful and meaningful way.

If you've worked through this entire book, lettering style by lettering style, you now have enough experience to move beyond the simple copying of alphabets. Before attempting to do layouts, though, it might be a good idea to practice what you've learned by writing out a few sentences in each hand. (Try the sentence, "The quick brown fox jumps over the lazy dog," which uses all the letters in the alphabet.). When practicing, use the transparent guide sheets, securing a sheet of tracing vellum over each before beginning. After you've done a few sentences, try your hand at a few simple lettering jobs, such as writing out your full name and address in each hand or listing the names of friends and family members.

Thumbnails and Rough Drafts

Now it's time to think about planning some simple layouts. Before beginning a piece, it's often very helpful to map out your ideas with a thumbnail sketch and a rough draft. By quickly sketching out the main elements of a design idea, you can immediately gain a sense of whether or not a design has potential.

A thumbnail is merely a small, *very* rough representation of text placement and size. The drawings at right show two examples of thumbnail sketches.

A rough draft is simply a prototype of your design. It is the pre-final rendering of your design using elements—pen size, ink/paint color, paper type and size, and so on—that are the same as or very close to those you will use in your final product.

The thumbnail sketch above is for a layout in which all the text is centered on the page; the thumbnail below is for a piece whose headings are centered but whose text (including a decorative capital letter) is flush left.

Eight Steps to a Good Layout

At the risk of oversimplifying what can be a very complex process, I have put together the following illustrated to-do list for creating a good design:

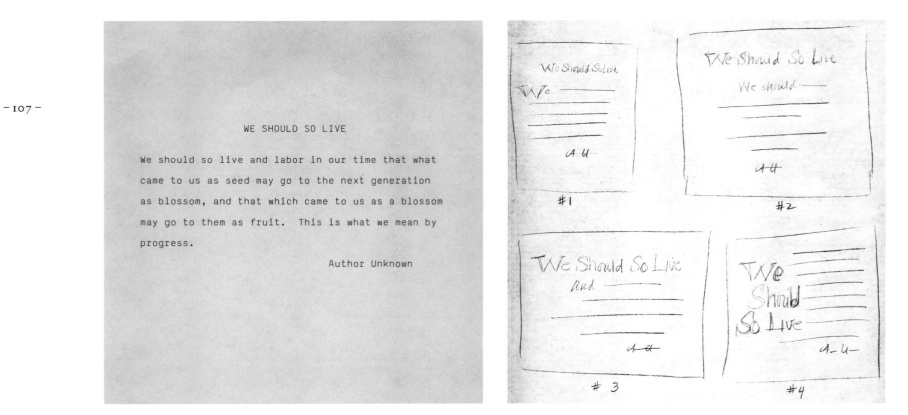

1. Begin with the text in typed form. If you are using text from a book or other printed document, it may be wise to retype the text in a simple block style so that you will not be influenced by the existing layout.

2. Using inexpensive paper and a pencil, work up several thumbnail sketches. Put down as many ideas as come to mind. Even try ideas that may not seem all that attractive in your mind, since it's sometimes surprising how well you'll like an idea when you see it on paper. By process of elimination, choose the one you like best.

3. Again using inexpensive paper and a pencil, write out the text following the layout you have chosen. Do this in your natural hand and without pre-drawn lines. This step will give you a rough idea of how the line spacing will work and approximately where on the finished sheet the artwork should be placed. Remember that using a different pen size for different elements (headings versus text) can add interest.

4. Establish approximate x-heights and spaces between writing lines by drawing pencil lines with your T square directly on top of the pencil writing. Decide which pen nib size is the best fit for each x-height you've approximated. Now, refine each x-height so that the proportion is in keeping with the style of lettering you plan to use for that line.

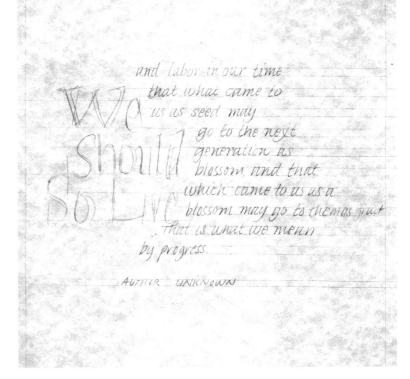

5. Still using inexpensive paper (cut it to the size of your final project), mark off borders/margins using the T square, and, as in step 4, draw the writing lines with your mechanical pencil and T square. Pencil-in the text—using the skeletal letter shapes for the particular hand you've chosen—in the size and position you want for your final, finished piece. Now, using the pen(s) you will be using for the finished piece, write out some—or all—of the text. Seeing this draft will allow you to establish exactly how many lines of text need to be lettered. It will also allow you to make any adjustments necessary when you work on the final version—for example, raising or lowering the position of the artwork on the paper, increasing or reducing margin sizes, fine-tuning x-height, and so on.

6. Now, cut your art paper to the final size of the finished piece, remembering to allow for margins as well as for mat space (if the piece is to be matted and framed). With light pencil lines, mark off all margins and areas that will not contain text; for example, if the piece will include a logo or photograph, lightly indicate that area in pencil. If the text is to be centered, drawing a pencil line down the center of the artwork area is helpful for positioning. Draw in the pencil guidelines, as you did in step 5. Pencil-in *all* text using skeletal letter forms for the lettering style you plan to use. Proofread your work *very carefully* before proceeding!

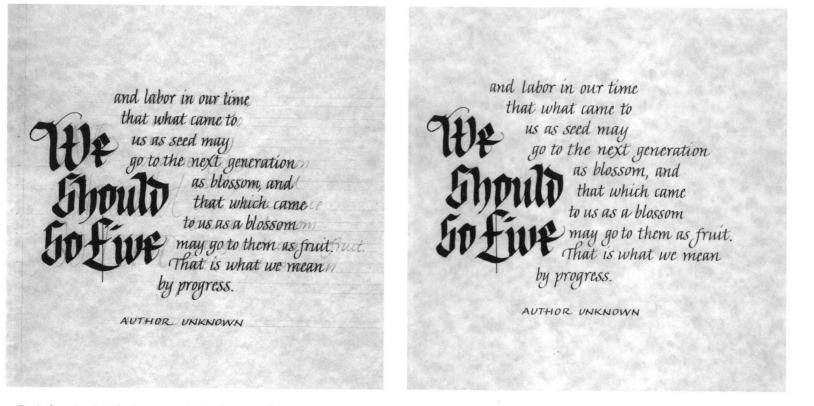

7. Begin lettering in ink. As a general rule, the text is inked first. After the text is dry, the headings and any gold or color decorations are added.

8. After allowing plenty of drying time (a minimum of overnight is recommended), carefully erase all pencil lines using a white plastic eraser.

Project Suggestions

I want to conclude this book by encouraging you to experiment with your own designs. With that in mind, I thought that I might suggest some brief quotations—one for each of the hands you've studied—for you to use as the texts for pieces that you lay out yourself. In creating these pieces, you may use the transparent guideline sheets and continue working with the 2mm pen nib, or, if you're feeling brave, you might try working with nibs of different sizes—making a paper ruler for each and drawing your own guidelines following the procedure described in the previous chapter.

For your Italic hand project, I suggest the following quotation, from American clergyman and writer Henry Van Dyke. The sentiment it expresses is certainly one that anybody beginning a new artistic endeavor should keep in mind:

Use what talents you possess:
The woods would be very silent if no birds sang there
except those that sang best.

For a first-time project using the Uncial and Half Uncial alphabets, the following quotation—attributed to an anonymous monk of the 12th century—seems especially appropriate:

Whoso knows not how to write
thinks it no trouble.

For your Carolingian hand project, I recommend this quotation, spoken by the great Native American leader Chief Seattle (after whom the city of Seattle is named):

Whatever befalls the earth,
befalls the son of earth.

And for your Gothic hand layout, I've chosen a quotation from Thomas Jefferson:

It is neither wealth nor splendor,
but tranquility and occupation,
which give happiness.

Finally, I've selected a verse from the Bible—from Proverbs 15:15—for your Foundational hand layout project. When we remember that western calligraphy was largely created by monks and was mainly used, at least during the earlier centuries, for the copying of the Bible and other religious books, it seems especially appropriate to end this book with a biblical quote.

He that is of a merry heart
hath a continual feast.

A Note on the Guide Sheets

The five transparent guide sheets that follow—one for each of the hands you've studied—are perforated and can easily be detached from the wire binding. Designed for use with a pen nib measuring 2mm across, the guide sheets should be used for many of the exercises in this book. (Consult the worksheet explanations for specific instructions.) The guide sheets will also be a valuable tool as you begin work on your own calligraphy projects. To use any of the guide sheets, detach it from the book's wire binding and place it on your drafting table, securing it with drafting tape. Place a sheet of tracing vellum on top of the guide sheet, and secure it with drafting tape, as well, as shown on page 96. Now you're ready to begin work.